Royal Benin Art

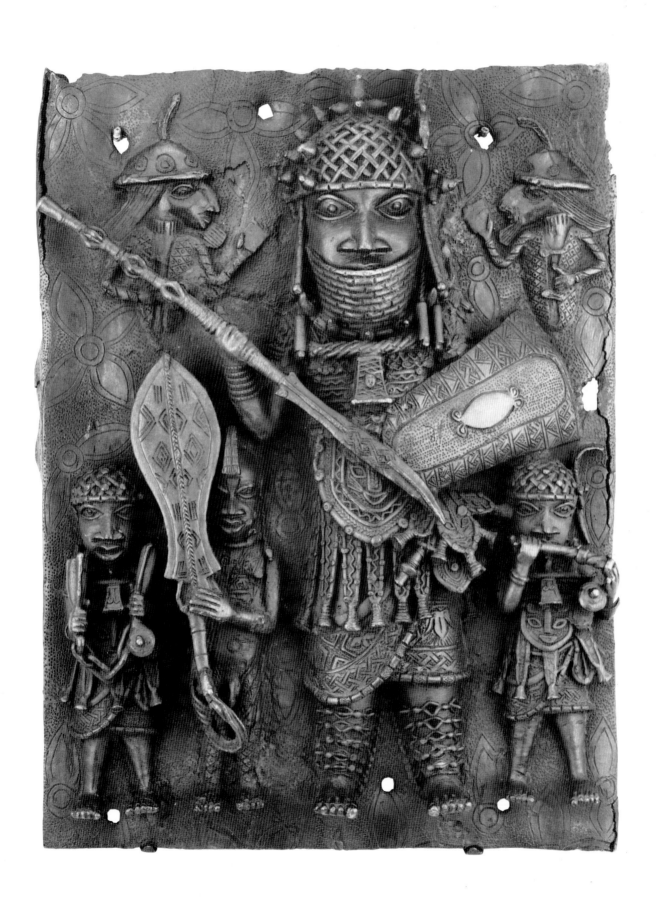

Royal Benin Art

IN THE COLLECTION OF THE
NATIONAL MUSEUM OF AFRICAN ART

Bryna Freyer

Published for the National Museum of African Art
by the Smithsonian Institution Press

Washington, D.C., and London

© 1987 Smithsonian Institution. All rights reserved
Printed in the United States of America

The paper used in this publication meets the minimum
requirements of the American National Standard for Permanence
of Paper for Printed Library Materials, Z39.48-1984.

Cover: Head of an Oba (cat. no. 2)
Frontispiece: Plaque: Multiple Figures (cat. no. 17)

Library of Congress Cataloging-in-Publication Data
National Museum of African Art (U.S.).
Royal Benin art in the collection of the National Museum of African Art.
Bibliography: p.
Supt. of Docs. no.: SI 1.2:R81
1. Art, Bini (African people)—Exhibitions.
2. Art, Primitive—Nigeria—Benin—Exhibitions.
3. National Museum of African Art (U.S.)—Exhibitions.
I. Freyer, Bryna, 1949– . II. Title.
N7399.N52B456 1987 730′.09669′30740153 87-42637
ISBN 0-87474-445-8 (alk. paper)

CONTENTS

FOREWORD

On November 26, 1957, the exhibition *The Classical Art of Negro Africa* opened to the public in New York City. It was organized by the Duveen-Graham Gallery in cooperation with the Minneapolis Institute of Arts. A copper-alloy relief plaque in that exhibition (no. 44) was illustrated and described in the accompanying catalogue:

> Bronze warrior, standing figure, holding sword. This fine bronze was part of the frieze in the Oba's palace. It was captured by the British Naval Brigade in 1897. Height, 17 in. Collection of Mr. Joseph Hirshhorn.

This plaque was the first traditional work of Benin art that Joseph H. Hirshhorn acquired. The same plaque appears in this catalogue, *Royal Benin Art in the Collection of the National Museum of African Art* (cat. no. 16). This collection information is as much a part of the history of the plaque as the information about its origin in the celebrated Nigerian kingdom of Benin.

For the art historian, tracing the collection history of a work of art is a fascinating endeavor. A collection history may help to establish an object's authenticity, date a work of art, define the taste of a period, or illuminate the personality of a collector or the purpose of a collecting institution. The findings become part of the permanent historical record that a museum maintains on works of art for future generations. For the majority of objects from Africa south of the Sahara, however, the collection trail must usually be abandoned in frustration. For centuries, records were poorly kept, if they were kept at all, because most African objects were initially brought to the West as curiosities, exotic specimens, or, as in the case of Benin, the spoils of war. To some extent, however, Benin art is one of the few exceptions to the art historian's often-thwarted efforts. The plaque described above is a case in point.

We know from the Duveen-Graham catalogue that the plaque was one of a large number of Benin works brought to Europe in 1897 after the conquest of Benin by a British naval expedition. A gap of sixty years then occurs in the collection history. In 1957, Abram Lerner, at that time curator of the Hirshhorn collection and subsequently the first director of the Hirshhorn Museum and Sculpture Garden, saw the plaque at the Duveen-Graham Gallery before the opening of the exhibition. He shared his enthusiasm and appreciation for this work of art with Hirshhorn and convinced him to look at the piece. Hirshhorn acquired the plaque and later lent it to the gallery for the exhibition.

Although this plaque was not the first piece of African art Hirshhorn acquired, it was his first acquisition of traditional Benin art. This fact prompts the question, What was it that attracted Hirshhorn, a collector of modern art, to the art of Benin? Admittedly, Lerner's enthusiasm may have been a factor. But in a conversation with me in 1987, Lerner explained Hirshhorn's initial interest in Benin art and admiration for it. "Joe was never consistent about only acquiring pieces of one tradition. He had this marvelous interest in all types of sculpture which at the time were called exotic. After acquiring this first [Benin] piece, he grew more passionate as time went on." Thus began the link between the collector and the renowned works of art from the kingdom of Benin.

In 1985 an internal Smithsonian relocation occurred in which non-Western works of art from the Hirshhorn Museum and Sculpture Garden were transferred to other appropriate Smithsonian museums. The plaque depicting a warrior and twenty-one other remarkable Benin works from the Hirshhorn collection are now a part of the collection of the National Museum of African Art. These works constitute a fine legacy.

It is a privilege to publish and exhibit these works of art created by the Benin guild of casters, but the museum's purpose goes further. Publishing these works and assuring scholarly and public access to them, it is to be hoped, will bring us closer to a full understanding of the Benin royal court and its history, to a resolution of questions about stylistic seriation, and to a determination of the precise metallurgical composition of the copper-alloy castings. All of these scholarly issues also point toward the need for a catalogue raisonné of Benin copper-alloy sculptures in the discipline of African art studies.

On behalf of the National Museum of African Art, I would like to thank my colleague James Demetrion, director of the Hirshhorn Museum and Sculpture Garden, who proposed the transfer of the collection, and Valerie Fletcher, associate curator in the Hirshhorn Museum's Department of Painting and Sculpture, who shared the knowledge about these objects that she gained by studying them over a period of years. This catalogue was written by Bryna Freyer, assistant curator, National Museum of African Art, whose meticulous approach to art historical research has earned her the admiration of the entire staff.

SYLVIA H. WILLIAMS
Director

PREFACE

This catalogue accompanies the exhibition of twenty-one works of art from the kingdom of Benin in the collection of the National Museum of African Art. They have previously been exhibited and published either individually or in small groups by the Hirshhorn Museum and Sculpture Garden and the National Museum of African Art. The museum hopes that this publication will make the collection accessible while additional research continues, particularly scientific testing of the metal objects.

The objects are given approximate dates based on the stylistic chronologies proposed by William B. Fagg and Philip Dark, with the exception of one male head, catalogue number 1. In 1982, while still privately owned, this head was thermoluminescence dated, and a metallographic report was done. The tests were performed at the Museum Applied Science Center for Archaeology, University of Pennsylvania, by Stuart Fleming, scientific director, and Vincent C. Pigott, research specialist. Flora S. Kaplan of New York University initiated the testing and made the results available to this museum.

The collection history of the objects is an area of continuing research. The majority of these works came out of Benin in 1897 with a British military expedition. As the provenance listings accompanying the catalogue entries indicate, there are still gaps to be filled. For example, the ownership of one head, catalogue number 3, is unknown between 1899 and 1959. Similar gaps in provenance are found in catalogue numbers 2, 5, 7, 9, 13, 14, 15, 16, 18, 20, and 21. Seventeen of the objects in this exhibition were given by Joseph H. Hirshhorn to the Smithsonian Institution in two groups, the first in 1966 and the second in 1979. All seventeen were transferred from the Hirshhorn Museum to the National Museum of African Art in 1985.

This catalogue and exhibition would not have been possible without the contributions of many people. Particular credit and thanks are due to Valerie Fletcher, associate curator in the Hirshhorn Museum's Department of Painting and Sculpture, who was responsible for the original accessioning and cataloguing of the Hirshhorn gift. Susan Glenn, assistant archivist at the Smithsonian Institution Archives, was most helpful in making the records of the Hirshhorn collection available.

Thanks are also due to the staff of the National Museum of African Art for their patience, interest, and support. Special appreciation goes to Sylvia Williams, director, Roy Sieber, associate director, Philip Ravenhill, chief curator, and Andrea Nicolls, assistant curator, for their helpful comments on the manuscript. For their invaluable contributions to the catalogue, I thank Dean Trackman, editor, Christopher Jones, designer, and Jeffrey Ploskonka, photographer. Janet Stanley, librarian, and Judith Luskey, photographic archivist, offered their time and the resources of their departments. I am also grateful to Richard Franklin, exhibition designer; Caroline Michels, assistant to the designer; Stephen Mellor, conservator; Robin Chamberlin, assistant conservator; Lee Williams, registrar; Louise Trush, assistant registrar; Basil Arendse, exhibits production manager; Dennis Soiberman, exhibits maker; exhibits specialists Michael Jackson, Robert McLean, and Ben Newlon; Bob Fugelstat, mount maker; and Brenda Chalfin, archives assistant. Tujuanna Evans, curatorial department secretary, persevered through the many drafts and revisions.

The courtesy of Doran Ross, associate director of the Museum of Cultural History, University of California, and his staff in providing a comparative photograph is greatly appreciated. For the use of his invaluable field photographs, special thanks go to William Fagg. His distinguished scholarship is matched by his generosity in designating this museum as one of the institutions to receive a set of his photographs. His photographs were donated by Paul Tishman and catalogued by Dr. and Mrs. Jeffrey Hammer. The negatives were made available through the courtesy of the Royal Anthropological Institute, London, with the assistance of Chris Pinney.

This catalogue obviously owes a great deal to those scholars cited in the text and the bibliography. More subjective is the debt owed to the late Douglas Fraser of Columbia University for his teaching, particularly his seminar on Benin art.

To those inadvertently not acknowledged here, I offer my apology. While thanks are given to many for their assistance, any errors or discrepancies in the text remain the responsibility of the author.

INTRODUCTION

The kingdom of Benin was located in the tropical rain forest region of what is now Nigeria. Although the kingdom no longer exists, the culture of Benin survives. Today, the people of the Benin region call themselves and their language Edo. Benin City, once the capital of the kingdom, is now the capital of Nigeria's Bendel State.

The kingdom's name varied over time. The name Benin, allowing for certain variations in spelling, was adopted by Europeans for the kingdom and its capital city. It derived from Ubini, a name that was introduced by Ewedo, fourth *oba* (king) in the current dynasty (reigned c. 1255 or 1340), to mark his reorganization of the government. Ubini in turn supposedly derived from Ile-Ibinu, "The Land of Vexation," a foreign term attributed to the first oba, Eweka I (reigned c. 1200 or 1300), whose father was not Edo. Later, c. 1440, following another political realignment of oba and chiefs, Edo became the name of the kingdom (Ryder 1969, 6, 10).

Much of the history of Benin both in local oral traditions and in European accounts focuses on the oba. While various succession lists generally agree about the names of the obas and order of their reigns, specific dates often vary. The dates and events of early reigns, in particular, assume a certain mythological aspect (Bradbury 1973, 20–21). Most likely, the kingdom in its classic form probably began in the fourteenth century.[1] But exactly why a people living in scattered villages formed a highly centralized kingdom with a capital city is unclear. The site of Benin City does not offer any particular geographical justification for its growth and importance. Other areas have greater agricultural potential, natural resources, natural defenses, and accessibility to trade routes (Ben-Amos 1980, 5).

The kingdom was held together by the strength of the oba and his court. The oba headed the complex political and social organization of Benin, an organization marked by widespread competition for power, prestige, and wealth. Three groups of chiefs supported the oba—the palace chiefs, the town chiefs, and the Uzama (senior hereditary chiefs).

The *edaiken* (crown prince) was considered one of the Uzama. The various chiefs served as attendants, government bureaucrats, military leaders, and guardians of traditional morality. In addition, the mother of the reigning oba was officially installed as the *iyoba* (queen mother; also *iye oba*). She could offer political, military, and spiritual advice and support. Specialized occupations, particularly artists and craftsmen, were organized into structured groups similar to medieval European guilds. Membership in the guilds was hereditary and provided opportunities for wealth and increased status. Some, such as the casters' and ivory carvers' guilds, were largely restricted to royal patronage.

In Benin City, the different court groups lived in separate areas (fig. 2, p. 12). The iyoba, the edaiken, and the Uzama lived outside of the central city. In the central city, the oba and the palace chiefs lived on one side of a dividing road, and the town chiefs lived on the other side. The members of the guilds lived in wards on the town chiefs' side, but some of those enjoying royal patronage worked in the palace. The commoners lived in villages throughout the kingdom under the immediate leadership of their elders.

The 1481 accession of a distant Portuguese king, John II (1455–95), led to a new era in Benin history and art. King John furthered Portuguese exploration of the African coast. Besides trade, the Portuguese were interested in finding the legendary Christian king Prester John[2] and in converting Africans to Christianity (Ryder 1969, 28–29). When the Portuguese reached Benin about 1486, they found a flourishing kingdom and a desirable trading partner. The Edo readily accepted European trade goods and integrated them into the culture. European religion, however, was not accepted. Catholic missionary activity, because it challenged the religious and political authority of the oba, became a source of dispute between Europe and the Benin court.

Over the centuries, the kingdom experienced pe-

1. Earlier dates have been proposed. Jacob Egharevba (1960, 92) suggests c. 1170, based on his collection of local oral history.

2. Between the twelfth and sixteenth centuries, European legends told of Prester John, or more fully Presbyter John, a descendant of one of the Magi who was going to drive the Moslems from the Holy Land. At first it was believed he lived in India. After the mid-fourteenth century, Prester John's kingdom was said to be in Ethiopia and then in West Africa.

riods of calm and periods of turmoil. During the fifteenth and sixteenth centuries, both oral traditions and European accounts tell of a powerful expanding kingdom that mounted notable military campaigns (Ben-Amos 1980, 18–29; cat. no. 19). In the seventeenth century, despite an idealized engraving that depicts the procession of a powerful oba (fig. 3, p. 15), the kingdom was torn by internal conflicts and rebellions over royal succession (Ben-Amos 1980, 33). By the eighteenth century, strong obas reunited the kingdom, and court art bolstered the role of the oba. The nineteenth century was a period of conflict and decline for Benin. To the north, the Islamized Nupe people of Bida (also known as the Nupe-Fulani) collected tribute from northern Edo villages (Bradbury 1973, 50). Meanwhile, England supplanted Portugal and the Netherlands in the region and became a resident colonial power rather than an equal noninterfering trading partner.[3] British trade interest in palm oil shifted established commercial patterns away from Benin and toward the Niger River Delta and the Cross River in the southeast. Further, the relatively favorable European view of Benin began to change. Disparaging accounts by travelers and British government officials portrayed Benin as a decaying city where slavery and human sacrifice were widespread. The impasse created by the British desire to exercise authority over Benin, especially in the areas of trade and capital punishment, and the oba's insistence on maintaining control in his realm eventually led to the destruction of the Benin Kingdom.

In January of 1897, the sixtieth year of Queen Victoria's reign, James Phillips (1863–97), newly appointed deputy commissioner and deputy consul-general of the Niger Coast Protectorate, set off for Benin with eight other unarmed Englishmen and about two hundred African bearers (Bacon 1897; Home 1982). The expedition was undertaken during the period when Oba Ovonramwen (reigned 1888–97; d. 1914) was performing ceremonies to honor his ancestors, a time when he would not receive visitors. It is unclear whether Phillips was motivated by ambition to establish himself in his new post or by a humanitarian desire to prevent human sacrifices. It is also unclear whether the oba was aware of his chiefs' actions to stop Phillips before he reached Benin. In any case, on the forest road to Benin, warriors attacked Phillips' party. Only two Englishmen and about sixty African bearers survived the attack. With astonishing speed, the British navy was dispatched on a so-called punitive expedition, and in February 1897 Benin City was captured. Buildings were razed and fires—some probably accidental, some not—damaged the town and palaces. The British exiled the oba and took the royal art treasures. They believed that removal of the art objects was essential to deter a revival of sacrificial practices and to weaken the power of the Benin monarchy. Later, the objects were dispersed into public and private collections in Europe.

Benin royal art encompasses a wide variety of objects. Some objects were created for palace walls and shrines, and others served as items of regalia. The heads, figures, pendants, plaques, musical instrument, and vessel in this catalogue provide a representative sample of the items found in the Benin court. One object, the three-dimensional mudfish, is unique, and its use is unknown (cat. no. 7). In contrast, the eight plaques shown here are among the approximately nine hundred plaques in public and private collections (cat. nos. 11–18). A comprehensive list of Benin art would also include costumes, staffs, fans, stools, armlets, and boxes, as well as other types of figures (equestrians, musicians, royal groups, female heads), pendants, plaques, and musical instruments.

Like the art of any wealthy court, Benin art is characterized by rich materials and complex symbolic imagery. Artists used materials such as bronze, brass, iron, ivory, wood, beads, cloth, and animal

3. Portuguese trade with Benin declined in the second half of the sixteenth century as Portugal's relatively limited resources were committed to the East Indies and Brazil. Similarly, the Dutch could not maintain their trading outposts after the 1730s. Although in the mid-eighteenth century various European nations were engaged in the slave trade, by the end of that century the British were blocking the slave trade (Ryder 1969, 75, 192, 231).

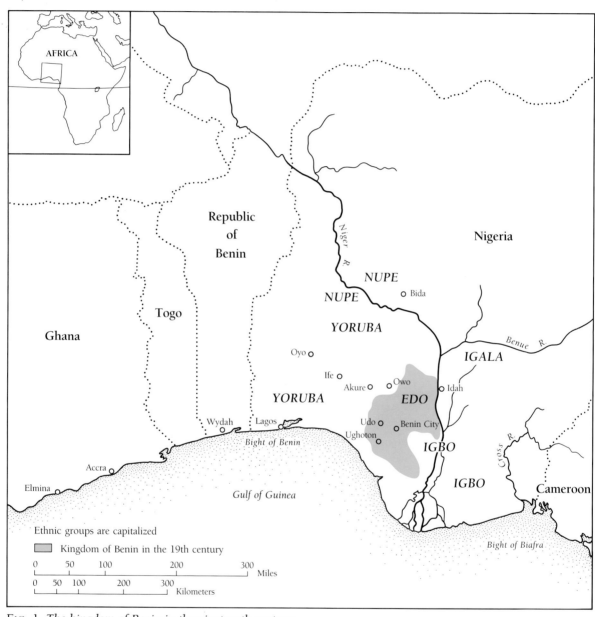

FIG. 1. *The kingdom of Benin in the nineteenth century.*

11

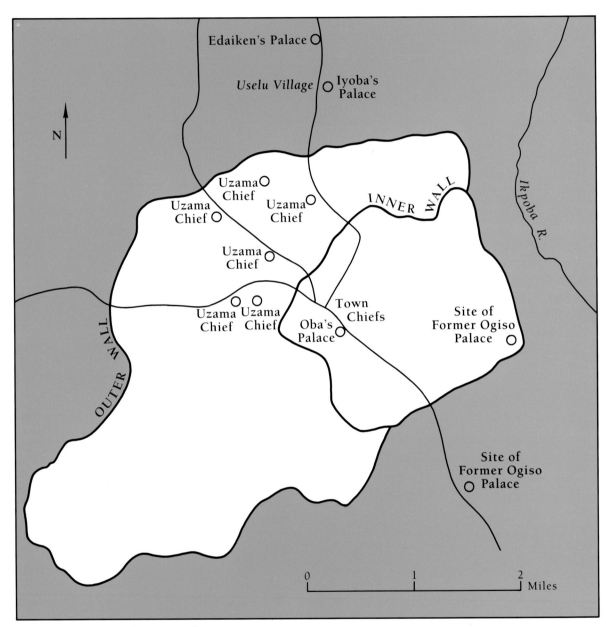

Edaiken's Palace ○

Uselu Village ○ Iyoba's
Palace

INNER WALL

Ikpoba R.

Uzama ○
Chief

Uzama ○
Chief Uzama ○
Chief

Uzama ○
Chief

OUTER WALL

○ ○
Uzama Uzama Town
Chief Chief Chiefs

Oba's ○
Palace Site of
Former Ogiso
Palace ○

Site of
Former Ogiso
○ Palace

N

0 1 2
⊢———————⊢———————⊢ Miles

FIG. 2. *Benin City in the nineteenth century.*

12

skins. All but one of the objects in this catalogue are castings made of copper alloy, the so-called bronzes of popular literature.[4] Cast copper-alloy objects were the most prestigious works of art in the Benin court, and they represent the apex of Benin artistic and technical achievement. The final piece in this catalogue is an ivory spoon, which was made for export. Ivory was also used locally by the oba for pendants, armlets, gongs, and figures. Whole tusks were carved with rows of figures and placed on ancestral altars (fig. 5, p. 19).

Cast objects were made by the lost-wax method. In this technique, wax was modeled over a shaped clay core. In some objects, iron rods were used as interior frames for extra support; the rods are detectable in the finished pieces by using a magnet (cat. nos. 9, 19). Skillful handling of the wax enabled the artist to include fine surface details. After modeling, wax extensions, or sprues, were added to provide space for pour channels and gas vents. The entire object was invested in a layered mold of fine to coarse clays. It was then heated, and the melted wax was poured off. Molten metal was added to the mold, replacing the "lost wax." After cooling, the mold was broken to release the metal object. Finally, remaining traces of the mold and accessible core material were removed, and the surface was polished. Because the mold was broken in the process, lost-wax casting created unique pieces rather than a series of identical objects, although close similarities within object types do exist (cat. nos. 17–18).

Certain traits are common to most Benin art objects. First, there is an emphasis on frontality. Because most heads and figures were placed on altars, they were designed to be viewed primarily from the front. The plaques, which were attached to the palace walls, also must obviously be viewed from the front. Secondly, objects with more than one figure, such as altarpieces (fig. 5, p. 19; fig. 8, p. 34) or

plaques (cat. nos. 17–18), often employ a hierarchical perspective: the size and the placement of a figure are determined by importance rather than by distance in space. Thirdly, Benin art displays a fascination with surface pattern and texture. Patterns often fill any available space. A leaflike design, for example, covers the backgrounds of the plaques (cat. nos. 11–18). Layers of costume likewise cover the human body, a style seen in actual court events as well as in art (fig. 4, p. 17; fig. 7, p. 25).

In viewing Benin art objects, the basic subject matter is often quite clear—a human head, a trio of male figures, a fish. The symbolic meaning—the iconography—requires interpretation based on knowledge of the kingdom's culture and history. Unfortunately, much information about Benin remains unknown.

Provenance, the history of ownership, is another important aspect of the study of Benin art. Tracing the ownership of a piece since it left Africa helps authenticate it and provides information on possible repairs, restorations, and surface treatments.

Of particular interest in this collection are seven objects formerly owned by General Augustus Lane-Fox Pitt-Rivers (1827–1900), an early major collector and student of Benin art (cat. nos. 1, 6, 8, 12–13, 18–19). Pitt-Rivers was not involved in England's African campaigns. Instead, he purchased his objects soon after the 1897 punitive expedition. His primary source was the active Bicester dealer W. D. Webster. The scope of the now-dispersed collection can still be seen in the catalogue that Pitt-Rivers privately published in 1900.

Pitt-Rivers' catalogue was not the only early published information about Benin. The 1897 massacre and subsequent punitive expedition generated a great deal of public interest in Benin. A number of sensationalistic newspaper stories refer to Benin as the "City of Blood." Some involved in the expedition published books, including a relatively straightforward account by Reginald Bacon (1863–1947), the expedition's intelligence officer (Bacon 1897). In these early general accounts, the art objects, if mentioned favorably, are often considered to have been

4. *Copper alloy* is the preferred term for an unanalyzed copper-based metal. Bronze is copper combined with tin, and brass is copper combined with zinc. Both alloys were used in Benin with small amounts of other elements. See footnote 7, p. 18, for the metal analysis of catalogue number 1.

of non-Benin origin or influence (e.g., Egypt, Portugal). Many of the military men brought home objects as mementos and sometimes sold them cheaply. One of the objects in this collection, a royal head, is illustrated in Webster's August 1899 sales catalogue with a price of only thirty pounds (cat. no. 3). Even allowing for change in the value of the pound and for the growth of the international art market, this price seems unbelievably low.

Three other early publications that consider the Benin sculptures as art are of enduring value. In 1899, the British Museum published a folio by Sir Charles Hercules Read (1857–1929) and Ormonde Maddock Dalton (1866–1945), staff members of the museum's Department of British and Medieval Antiquities and Ethnography. The authors explain how the British Museum's collection of Benin art, as well as its collection of sixteenth-century West African export ivories and traditional ivories, was formed with government and private donations. They give field collection data and even include the results of a rudimentary metal analysis of some Benin pieces. A 1903 book by H. Ling Roth (1855–1925) and a massive 1919 book by Felix von Luschan (1854–1924) try to place the art in context with field photographs, narratives, and historical information. Roth, keeper of the Bankfield Museum in Halifax,[5] was the brother of Dr. Felix Roth, a medical officer on the punitive expedition. In addition to extracts from his brother's papers, Roth's book contains a pithy censure of the British government for auctioning the Benin objects and thus allowing many to end up in German museums rather than British museums. Luschan, an anthropologist and ethnographer, was a staff member and eventually director of Africa and Oceania at the Museum für Völkerkunde in Berlin. He arranged purchases of Benin art objects from dealers in London, making the Berlin museum's holdings the world's largest until many were either lost or destroyed in World War II. His book is still the most complete published visual record of

Benin art objects. The book also compares certain Benin objects and regalia with European trade items that possibly served as prototypes.

Over the two decades following Luschan's book, interest in Benin continued. A British colonial administrator, P. Amaury Talbot (1877–1945), wrote a major ethnographic study in 1926 based on the 1921 census of the southern provinces of Nigeria. In the 1930s, the late Jacob Egharevba, a Benin chief in the Iwebo palace association and an honorary curator of the Benin Museum, recorded local oral traditions in a series of pamphlets, which were later revised and published as books. Egharevba interviewed Benin elders who were active in the pre-1897 court.

Since the 1950s research on Benin has intensified. Nigeria has built a collection of exceptional aesthetic quality and cultural merit through government purchases abroad, repatriation of objects, and donations of objects from Benin notables. Because of the efforts of Dr. Ekpo Eyo, retired director of Nigeria's Federal Department of Antiquities, and his colleagues, Benin objects and other Nigerian archaeological treasures have been shared worldwide in touring exhibitions and companion publications (Eyo 1977; Eyo and Willett, 1980). Elsewhere, scholars such as historian Alan Ryder and ethnographer R. E. Bradbury have produced major publications based on old European documents and Edo oral traditions. The art objects themselves are the focus of continuing interdisciplinary approaches involving art history, anthropology, archaeology, and technical analysis. Recent iconographic studies, such as those by Paula Ben-Amos, Barbara Blackmun, and Joseph Nevadomsky, primarily relate art objects to surviving traditions.

Tentative chronologies for different types of objects (e.g., heads, plaques) have been developed and continue to be refined. Such theoretical dating frameworks correlate extensive stylistic analyses with references in oral and written records. Most notable are the chronologies of William B. Fagg (1963) and Philip Dark (1973). For many years, Fagg was keeper of ethnography at the British Mu-

5. *Keeper* is a British term for "curator," although often the position includes administrative duties.

14

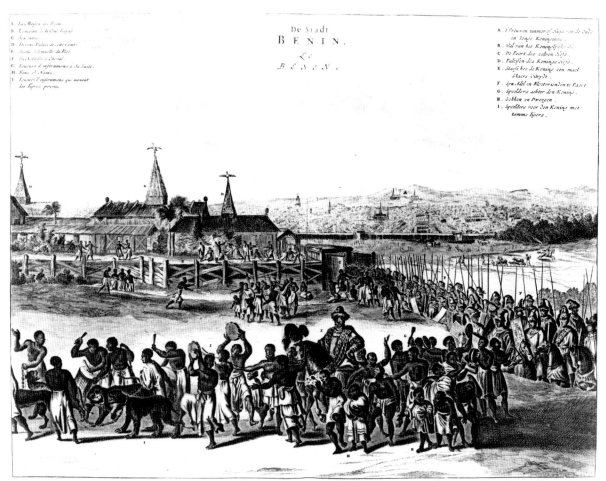

FIG. 3. *This seventeenth-century engraving depicts the spectacle of the Benin royal court. The oba, on horseback, is surrounded by warriors, musicians, dwarfs, and leopards. In the background, a wall separates the turreted palace from the town. From Olfert Dapper,* Description de l'Afrique, *1686.*

seum. Dark has specialized in Benin art studies since the 1950s.

While it is common to emphasize the continuity of art and culture in studying traditional African communities, such communities are not static. In Benin, social and political developments, such as the numerous contacts with neighboring Yoruba kingdoms over the centuries, the introduction of Christianity and Islam, and the formation of the country of Nigeria, influenced the art and culture of Benin. The degree to which relatively contemporary field data can be applied to objects from previous centuries, therefore, is a topic of scholarly debate.

Questions about the development of Benin art, specifically the origin of metal casting, may be answered by specialized technical approaches. Archaeological excavations at Benin, such as those from 1961 to 1964 by Graham Connah (1975), have yielded information about the city's walls and habitation sites, but little has been discovered that directly relates to the art objects now in collections. Excavations have not been extensive or systematic in part because Benin is still a living culture with a contemporary city and an active, though smaller, palace and court. Ongoing museum research is making use of sophisticated scientific testing methods. Irwin Tunis (1981), for example, combines testing of materials with visual analysis of large numbers of objects. Spectrographic and lead isotope tests are gradually providing detailed information about the exact metallic composition of cast works. A chronology suggested by Otto Werner is based largely on such testing, which has found that the nickel content in the copper alloys increased over time (Werner in Herbert 1984, 98–99). Thermoluminescence dating, a complex and easily contaminated technique for determining the age of fired clay, is being used to date the clay cores of Benin copper-alloy casts.

The art history of the Benin Kingdom is complex and not yet completely understood. This catalogue and the exhibition it accompanies are meant to offer an introduction to the kingdom's art. The collection is divided into three sections: "The Oba," objects owned by or depicting the oba; "The Court," objects used by or depicting members of the court; and "Foreigners," objects depicting Europeans or their influence. Some of these divisions overlap, and objects in one section could well have been placed in another.

15

THE OBA

Edo oral tradition recounts that Benin was first governed by the Ogiso dynasty, the "rulers of the sky" (Ben-Amos 1980, 13). The actual number of rulers and the durations of their reigns vary in the myths about the Ogiso period. An eventual rebellion against the Ogiso was settled when a group of chiefs or elders invited an outsider to be ruler (Bradbury 1973, 44). Popular belief now identifies the outsider as Oranmiyan, a son of the divine king of the Yoruba city of Ife to the west. Oranmiyan himself did not rule. He married an Edo woman, and their son Eweka I became oba, beginning the present ruling dynasty. Eweka I probably came to power about A.D. 1300. Fifteenth-century Portuguese accounts, however, tell of Benin deferring to a ruler who lived east of Benin called the *ogane* (also *oghene*) (Ryder 1969, 7, 31).

In the Edo ideal, an oba was the ultimate symbol of his people and land, yet he was also different from them. The plan of Benin City reinforced the distinctness of the oba. The walled circular city was divided by a road; the oba and his palace attendants lived on one side and the town chiefs and general population lived on the other (fig. 2, p. 12). The oba was different in another important way. He was a divine ruler, a living god whose good health assured the well-being of the kingdom. The people did not see him eat, take ill, or die. Within the Benin kingdom, only the oba could order the death of a man. The kingdom's territorial extent at any time was determined by where the oba was accepted as the arbiter of life and death (Bradbury 1973, 46). In art, depictions of predatory animals, such as leopards and pythons, compare the considerable power of the "rulers of the wild" with the even greater power of the oba, ruler of the kingdom.

The Igue ceremony, still practiced today, was one of the most important ceremonies of the ritual calendar. It strengthened the oba's spiritual powers through the application of herbal mixtures associated with the power of the forest (fig. 4) and through the sacrifice of symbolically powerful animals such as leopards or vulturine fish eagles[6] (Bradbury field notes cited in Ben-Amos 1980, 88). No one

6. The vulturine fish eagle is a large bird, also known as the palm-nut vulture (*Gyphohierax angolensis*). The oil from the palm nuts on which the bird feeds makes its face featherless like a vulture's.

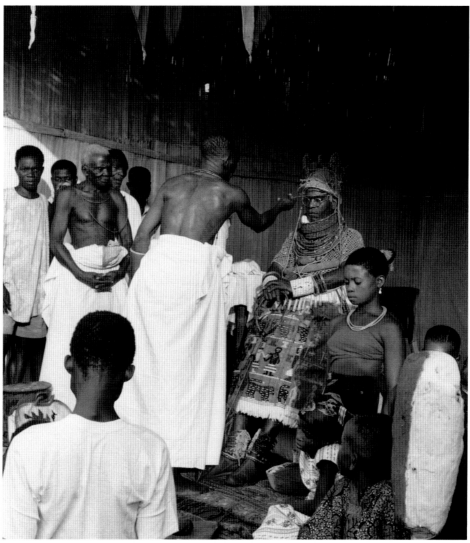

FIG. 4. *Oba Akenzua II, seated, wears a rare traditional handwoven wrapper during the Igue ceremony. A ritual specialist anoints his head with medicines. Photograph by W. B. Fagg, 1958.*

but the oba sacrificed animals symbolic of kingship (Ben-Amos 1976, 246–48).

The hierarchy of power from oba to titleholders to commoners was reflected in the sculpture and the regalia. The oba not only owned more regalia, he decided what others might own by assigning regalia to titleholders. The oba had a monopoly on ivory, cast copper-alloy objects, and coral beads, although he did allow others to have them in numbers based on rank. This system of royal art patronage and control changed greatly with the 1897 destruction of the palace and the exile of the oba. When the British allowed a new oba to return in 1914, the palace shrines were rebuilt and the artists took up their work again. But previously restricted items, such as cast copper-alloy objects, were permitted to be sold in the market, as they are today.

COMMEMORATIVE HEADS

These three copper-alloy male heads[7] represent one of the larger categories of Benin sculpture. At least 150 similar heads are extant (Dark 1982, 2.4.5–6). Other types of individual heads also exist in copper alloy, fired clay, or wood. The general emphasis on the human head in Benin art is seen as well in the proportionately large heads of full-length figures (cat. no. 4). Perhaps this artistic convention expresses a belief, still current in Benin, that it is the head that "leads one through life." A person's fate is thought to depend on qualities (thinking, judgment, will power) and senses (hearing, sight, speech) that are associated with the head (Bradbury 1973, 263).

Copper-alloy heads, such as these three, share other symbolic associations. In Benin today, the red color and shiny surface of the metal are regarded as both beautiful and frightening (Ben-Amos 1980, 15). The original reddish patina of the copper alloy, enhanced by the local red earth (laterite) that adheres to objects placed outdoors, was more apparent on most pieces before time darkened the metal and foreign collectors changed surfaces with chemical polishes and waxes. Least altered in the collection of the National Museum of African Art are male head number 1, recently treated by conservators, and a plaque that still has a coating of red earth (cat. no. 11). Copper alloy is also valued because, unlike iron or wood, it does not decay—an appropriate metaphor for a divine ruler whose illness or death is not publicly acknowledged.

Iron is inlaid in the eyes of many heads and in the double vertical forehead marks that appear on some heads. The inlaid eyes and forehead marks represent the piercing stare of a powerful person and the lowered brows of determination or maturity (Nevadomsky 1986, 42). The two inlaid forehead marks should not be confused with the three raised marks

above each eye on many heads. The latter are keloids and indicate an Edo male (cat. nos. 2–3). Four keloids indicate either a non-Edo African male (cat. no. 1) or an Edo female (fig. 8, p. 34).

The style differences among the heads, scholars explain, reflect a progression of styles over time or distinct functions or a combination of both. William Fagg divides the heads stylistically into three periods: early period, from the fifteenth to the mid-sixteenth century; middle period, from the mid-sixteenth to the late seventeenth century; and late period, from the eighteenth to the nineteenth century (Fagg 1963, 32, 35, 37). These periods, corresponding to catalogue numbers 1, 2, and 3, respectively, are based on styles ranging from greater naturalism to greater abstraction and from simple to heavily ornate regalia. Philip Dark (1975) further refines and divides these divisions, but he retains Fagg's basic concept of style development. A seriation that places the most naturalistic heads first is compatible with the widespread theory, supported by some local accounts, that casting skills in Benin derive from Ife, sacred city of the Yoruba peoples. Ife is famed for the naturalism of its ancient art.

Both Fagg and Dark believe heads function as royal commemorative objects. From the early eighteenth century to the present day, foreign visitors to Benin City have observed finely cast heads, some supporting carved tusks, on ancestral altars in the royal palace. The altar groupings were destroyed in 1897 when many objects were removed by the British military and a fire swept the palace. With the restoration of the Benin monarchy in 1914, the new oba, Eweka II (d. 1933), commissioned heads and other objects for an altar dedicated to his father, Oba Ovonramwen (reigned 1888–97; d. 1914) (fig. 5).

An alternative explanation for heads that look like head number 1 is that they were used as trophy heads and may therefore have been produced at the same time as the more elaborate heads (Ben-Amos 1980, 18). This function would explain the relative lack of regalia and the non-Edo marks above the eyes. A contemporary chief of the casters' guild recounts that in early times conquered kings were be-

7. The copper alloy of catalogue number 1 is composed of the following elements: copper (94.4 percent), tin (3.4 percent), zinc (0.88 percent), lead (0.42 percent), arsenic (0.44 percent), antimony (0.20 percent), iron (0.19 percent), nickel (0.060 percent), silver (0.11 percent), silicon (0.018 percent), aluminum (0.13 percent), and chlorine (0.014 percent).

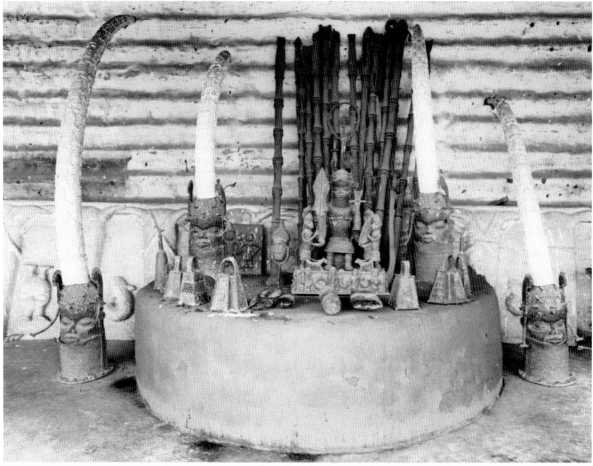

FIG. 5. *Dedicated in 1914 to Oba Ovonramwen, this altar displays modern versions of traditional objects. Photograph by Eliot Elisofon, 1970.*

headed. Cast heads were made of "the most stubborn" to serve as warnings to their successors. The cast heads were kept on altars in Benin (Ben-Amos 1980, 18).

A German businessman who lived in Lagos before the 1897 punitive expedition, identified only as Mr. Erdmann, photographed a large iron staff that held several heads similar to head number 1 (fig. 6, p. 20). Unfortunately, no additional information survives, and the photograph exists only as a damaged image supplied by Erdmann's widow to Felix von Luschan ([1919] 1968, fig. 515). The iron staff has recently been identified as an Osun medicine staff (Osun is the deity of healers). Much smaller versions were carried into battle, and the heads of slain enemies were placed on them (Nevadomsky 1986, 43).

Scientific analysis of head number 1 indicates a comparatively early date for its creation, between the late fourteenth and the early fifteenth century (dated 1485 or 1525 by thermoluminescence tests). It is possible that some, if not all, of the so-called trophy heads are in fact also "early period" without necessarily sharing a function or a stylistic seriation with the more elaborate heads.

The heads, like much of Benin art, are relatively naturalistic—they have obviously human features in the proper number, arrangement, and proportion. Differences do occur, however, in the degree of modeling and expression. The heads are not realistic portraits. Instead, the standardization within types and the emphasis on regalia suggest that it is the individual's role in society that is important, not his personality. Head number 1 combines more naturalistically modeled facial surfaces with a detailed but unadorned hairstyle and a tight beaded collar. Heads number 2 and number 3 are almost cylindrical and depict an oba's elaborate regalia of coral and stone beadwork. The high collars, called *odigba*, completely cover the neck and chin.

The beadwork crowns on heads number 2 and number 3 are but two of the many types associated with the obas of Benin. While a particular style of crown may be associated in oral history with a particular oba, in art history the interpretation is not as clearly defined. For example, beaded winglike shapes extending upward from the sides of a crown were supposedly introduced by Oba Osemwede, who reigned from 1816 to 1848. Head number 3 depicts this style, although one of the attachments has broken off the crown. In a number of pre-nineteenth-century relief images on ivory, however, obas wear crowns with similar attachments, which

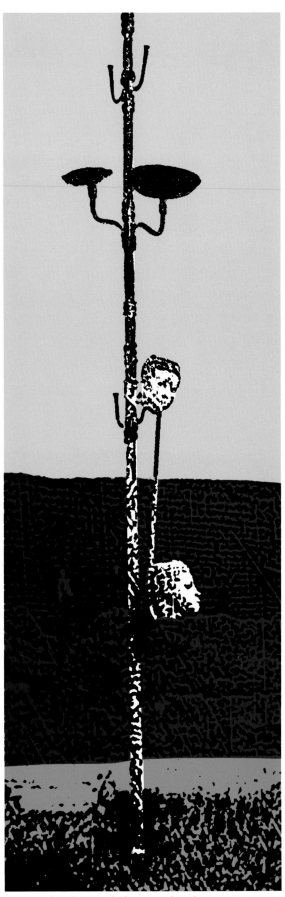

FIG. 6. *This damaged photograph, taken in 1897 by a German businessman identified only as Mr. Erdmann, documents the display of cast heads on a staff. From Felix von Luschan,* Die Altertümer von Benin, *1919. (Photograph retouched.)*

are said to symbolize the barbels, or whiskers, of mudfish (cat. no. 7) (Blackmun 1984, 294). In addition, at least three of the pre-nineteenth-century plaques show single-wing crowns, also implying a tradition of such crown attachments that dates before the time of Oba Osemwede (cat. nos. 17–18; Berlin Museum für Völkerkunde, III.C.7657) (Tunis 1981, 86–87).

Animal symbolism may appear in more abstract or more naturalistic form than the crown attachments. On heads number 2 and number 3, the large bead at the center of the forehead is called *atolekpe hae*, "you can never touch a leopard's forehead," a reference to the leopard as a royal symbol (Bradbury personal communication in Dark 1975, 42). A leopard also appears in naturalistic form on the flange at the base of head number 3. Also on the flange are a mudfish and a horned head that is either a bovine or a ram. Together these three animals suggest themes of sacrifice and power. All are used in sacrifices to honor the gods and the ancestors. Leopards are sacrificed only by the oba (Ben-Amos 1976, 248).

Other symbolic forms appear on the flange of head number 3. An oval shape (front center) possibly represents the kola nut, a sign of civilized behavior. It is still included in ritual offerings and is the symbolic food offered to guests. A triangular shape (back center) represents a "thunder stone." Thunder stones are prehistoric axes that the Edo regard as supernatural phenomena—physical manifestations of divine anger and retribution. They are often placed on ancestral altars. The final motif on the flange is an armlike elephant's trunk with a hand at the end holding three leaves. The elephant symbolizes strength or power, and the number three has associations with spiritual forces (Ben-Amos 1981 personal communication in Blackmun 1984, 273).

Provenance

Catalogue number 1:
Augustus Lane-Fox Pitt-Rivers, before 1900
Pitt-Rivers estate, 1900
Private collection, New York, before 1982

Catalogue number 2:
Private collection, England, 1897
Sotheby and Co., London, auction March 29, 1965
 (property of Mrs. E. C. Gaze and R. H. H. Barneby)
(Henri) Kamer Gallery, New York, 1967–68
Joseph H. Hirshhorn, 1968–79

Catalogue number 3:
W. D. Webster, Bicester, England, in catalogue no. 21, August 1899
Aaron Furman Gallery, New York, 1959
Joseph H. Hirshhorn, 1959–66

1 MALE HEAD
Late 14th–early 15th century
Cast copper alloy, iron inlay
H. 8¾ in. (22.2 cm)

Purchased with funds provided by the Smithsonian Institution Collection Acquisition Program, 1982
82-5-2

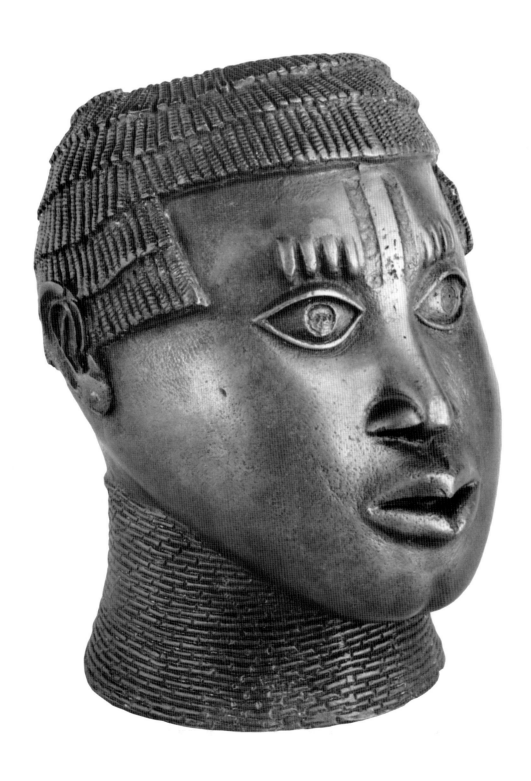

2 HEAD OF AN OBA
18th century
Cast copper alloy, iron inlay
H. 12¼ in. (31.1 cm)
Gift of Joseph H. Hirshhorn to the Smithsonian Institution
85-19-16

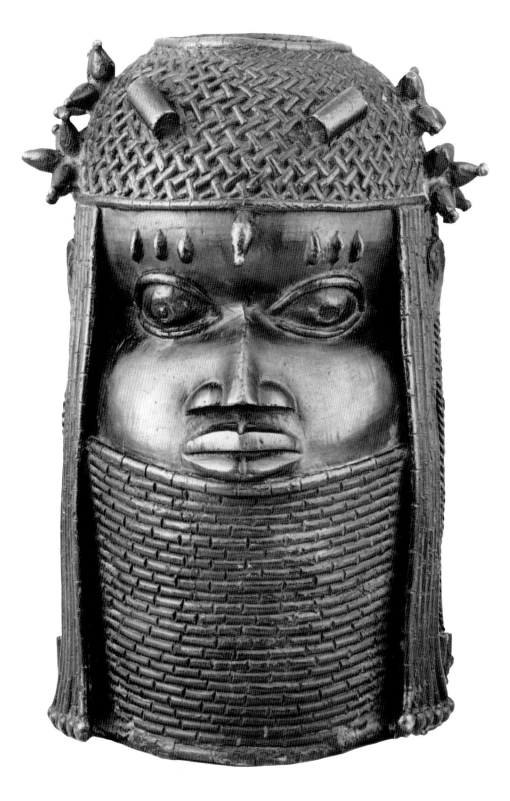

3 HEAD OF AN OBA
19th century
Cast copper alloy, iron inlay
H. 15 in. (38.1 cm)
Gift of Joseph H. Hirshhorn to the Smithsonian Institution
85-19-7

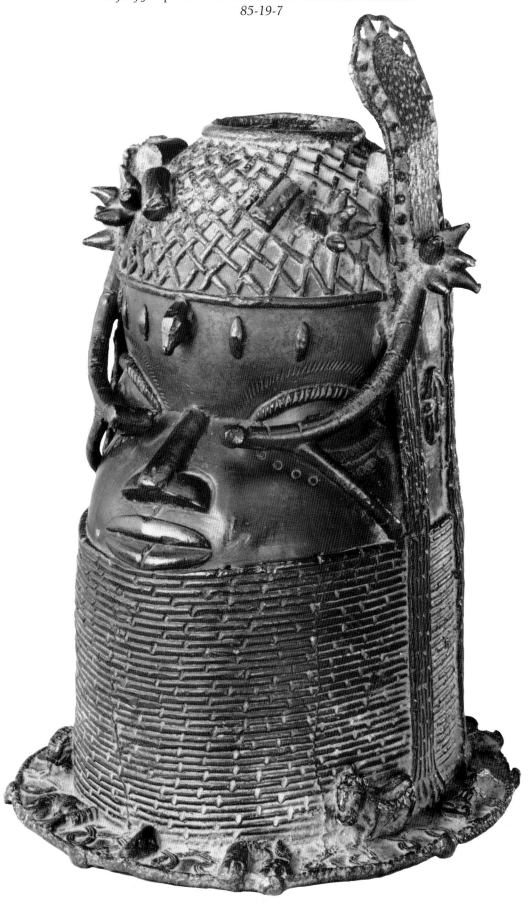

4 FIGURE OF AN OBA
19th century
Cast copper alloy
H. 16⅛ in. (41 cm)
Gift of Joseph H. Hirshhorn to the Smithsonian Institution
85-19-12

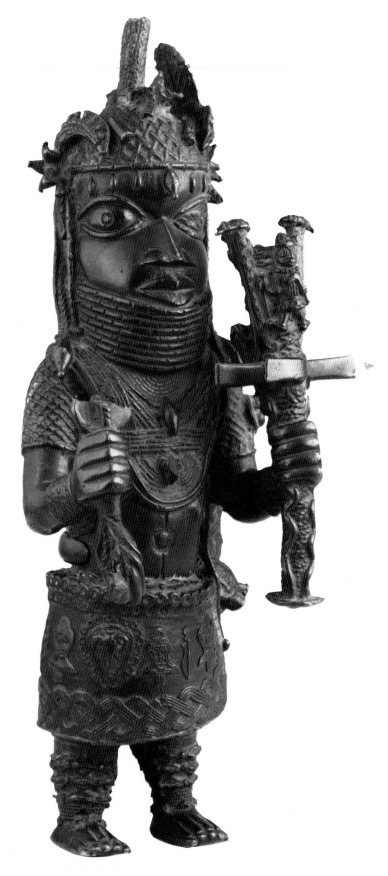

This figure of an oba is solid cast and weighs thirty-two pounds. Some parts of it have broken off. Originally, the oba held an *eben,* a ceremonial sword, in his right hand (cat. nos. 14–15, 17–18; fig. 9, p. 41). Also missing is a twisted loop, similar to the handle of an eben, that extended upward from the crown. The loop's height probably equaled about half the height of the oba's body, or approximately eight inches. The broken ends can be seen in front of and behind the stem top of the crown. Finally, traces remain of two sidepieces that projected from the beaded clusters on the figure's crown. The sidepieces were probably similar to those on the crown of catalogue number 3 and to those extending above the forehead of Oba Akenzua II (reigned 1933–78) in figure 7.

The figure's style typically emphasizes the formality of pose (stiff and frontal) and the head (proportionately large). Symbolically, the style is appropriate for an object that an oba intended to place on an altar dedicated to his predecessor (cf. cat. nos. 2–3). The hieratic image implies authority and power, and the head is the locus of inherent spiritual force.

The various items of traditional regalia on the figure appear on other art objects, and some survive in contemporary court regalia. Although shorter, the figure's wrapper appears to be related to the *iyerhuan,* or great wrapper, still worn by the oba on very important ceremonial occasions (fig. 4, p. 17). Its size makes the wearer appear larger. These handwoven brocaded cotton textiles, now rare, contain images referring to court life (Ben-Amos 1978, 53). This figure's wrapper, for example, is designed with ebens and bells. On each bell is an abstracted Portuguese face. Like the luxurious cloth, depictions of Portuguese symbolize wealth and power. Another image, a sacrificial ram's head on the figure's right hip, is not a design on the cloth but a representation of a copper-alloy pendant (cf. cat. no. 5).

Of great ritual and political significance are the stone and coral beads represented in the crown, high collar, necklaces, netted shirt, baldric, armlets, and anklets. Possession of the red royal beads—spiritually charged crown jewels from the treasure of the god Olokun—helps legitimize the wearer's right to rule (Ben-Amos 1980, 64, 68). The beads, possibly in particular the single large bead on the chest (cf. cat. no. 5), strengthen the oba's power to issue proclamations and to curse (Ben-Amos 1980, 68).

The object in the figure's left hand may serve as a proclamation staff, another object that enhanced the power of the word (Ben-Amos 1980, 66). It takes the basic form of a gong (*egogo*). Gongs made of iron are used as ordinary musical instruments (cat. no.

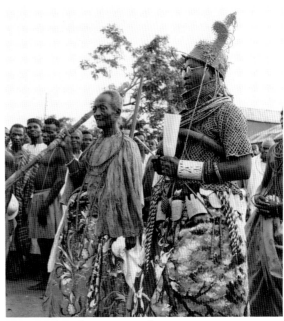

FIG. 7. *Oba Akenzua II strikes an ivory gong during the Emobo ceremony. He is wearing traditional coral beadwork and ivory ornaments. Photograph by W. B. Fagg, 1958.*

10). Gongs made of decorated copper alloy or ivory, rarer than iron gongs, are used for ceremonial functions. In the Emobo ceremony, for example, the oba strikes an ivory gong to drive away evil (fig. 7). Added to the basic gong are three projecting blades (the bent front blade was originally intended to project forward). The blades look like the head of the distinctive Benin blacksmith's finishing hammer, which is used to give the final shaping to an object. The figure in relief on the staff holds a blacksmith's hammer in his left hand.

As a divine ruler, a living god, the oba acts as a link with all the deities of the Benin pantheon and with the venerated ancestors. Some of the deities are symbolized on the staff. The pythons descending the staff symbolize Olokun, the sea god, and are often found on objects associated with the oba (cf. cat. no. 6). Three-dimensional versions of the relief figure holding a hammer have been identified as representations of a priest of Osanobua, the creator god (Ben-Amos 1980, 40). The blacksmith's hammer represents Ogun, the god of iron. At the 1979 coronation of Oba Erediauwa, members of the Ewaise guild of healers and diviners carried staffs identical in form to the one in this figure's hand. Made of iron, the Ewaise objects were identified as "protective Ogun staffs" (Nevadomsky 1984b, 54, fig. 10).

Provenance
Dr. J. P. Howe, 1897–1934
Sotheby and Co., London, auction November 20, 1961
 (property of Capt. J. S. Howe, 1934–61)
Joseph H. Hirshhorn, 1961–66

25

5 PENDANT WITH THREE FIGURES
Mid-16th–17th century
Cast copper alloy
H. 6⅞ in. (17.5 cm)
Gift of Joseph H. Hirshhorn to the Smithsonian Institution
85-19-17

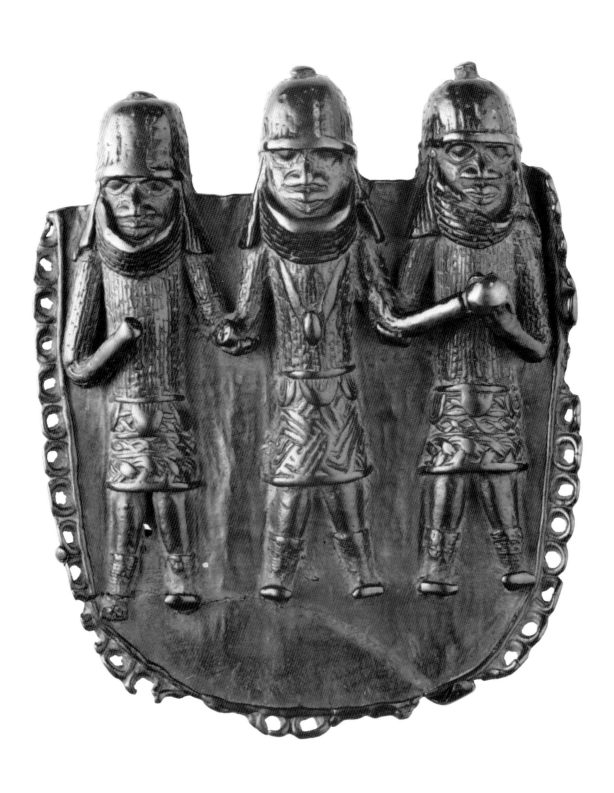

Semicircular pendants, also known as heraldic and aegis plaques, are found with a variety of animal and human images in relief. Pendants are worn around the waist on a belt. Oba Akenzua II was photographed on a ceremonial occasion in 1958 wearing a belt of ivory ornaments that included a three-figure pendant similar to this one (fig. 7, p. 25).

Pendants are often depicted on other cast objects. A figure of an oba, catalogue number 4, wears a single ram's-head pendant on the right hip. Architectural plaques with triadic scenes show the oba and his attendants wearing belts of pendants. The pendants worn by the three Benin nobles on this pendant appear as plain semicircles. Neither individual three-dimensional figures nor relief figures on plaques, however, wear three-figure pendants.

In Benin art, the relative importance of persons is usually indicated by size and costume (cat. nos. 17–18; fig. 8, p. 34). On this pendant, however, the three men are almost identical. The only distinctions are the more elaborate interlace pattern on the central figure's wrapper and the large single-bead pendant he wears around his neck. The hieratic poses and the abundance of beadwork regalia (shirts, collars, anklets) suggest that the figures are high-ranking personages who are probably enacting an important ritual.

The triadic composition seen on this pendant—a central royal figure who is flanked and supported by two attendants—is widespread in Benin art. Besides copper-alloy pendants, it is frequently found on plaques and among the motifs on carved ivory altar tusks. One triadic grouping on a pendant has been identified, based on field data, as a fifteenth-century oba, Oba Ohen, supported by the *edaiken* (crown prince) and the *ezomo* (war chief) (Talbot [1926] 1969, vol. 2, fig. 69). This identification may apply only to a variation of the triad in which the central figure's legs are mythical mudfish, symbol of the god Olokun (cat. no. 7).

It is customary at certain court occasions for the oba to be supported—held by his elbows and forearms—by special court officials. Although the edaiken and the ezomo are among the officials who may perform this service, the two high priests, the *osa* and the *osuan,* are more closely linked with the role (Blackmun 1984, 275; Forman, Forman, and Dark 1960, 38). The priests are court titleholders and caretakers of two state gods, Uwen and his wife Ora. These gods are associated with the founding of the royal lineage (Ben-Amos 1980, 93) and the continued fertility and well-being of the kingdom.

The triadic composition, both in art and in court ceremonies, is a basic reference to the political and social structure of kingship: while the oba sustains the country, he is literally supported in turn. Local stories refer to an oba who found the burdens of kingship too heavy and asked everyone in the kingdom to help him carry his crown. He devised four greetings, one each for the morning, afternoon, evening, and night, to ask for aid (Blackmun 1984, 275–76).

Finally, there is an unusual detail on the reverse side of this pendant. Depicted is an eben, a fanlike ceremonial sword with a loop handle (cat. nos. 14–18; fig. 9, p. 41). This design is found on the backs of at least six other pendants that have various motifs on their fronts: three figures, a crocodile head, a mudfish, and a woman with a gong.[8] The purpose of the eben design is unknown. Perhaps it is an artist's signature or a mark for a special group of pendants.

Provenance
(Henri) Kamer Gallery, New York, 1967–68
Joseph H. Hirshhorn, 1968–79

Back of pendant.

8. Three figures: Louis Carré, Paris; Han Coray, Zurich (Musée de l'Homme 1932, 17); anonymous private collection (Quarcoopome 1983, 100). Crocodile: Pitt-Rivers collection (Pitt-Rivers [1900] 1976, 65). Mudfish: Pitt-Rivers collection (Pitt-Rivers [1900] 1976, 72). Woman: Berlin Museum für Völkerkunde, III.C.9953 (Luschan [1919] 1968, fig. 72). According to Felix von Luschan, at least twenty pendants with sword motifs exist ([1919] 1968, 389).

6 Vessel

19th century
Cast copper alloy
H. 15 in. (38.1 cm)

Gift of Joseph H. Hirshhorn to the Smithsonian Institution
85-19-14

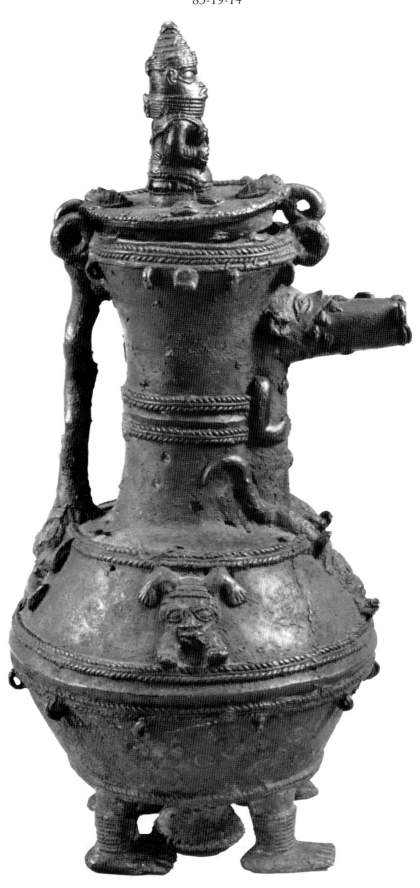

This vessel never held liquids. Its belly still contains the earthen casting core, accounting for the unwieldy weight of eighteen pounds. Because the surface was not polished after casting to remove minor flaws, most notably the ill-fitting lid, the vessel is probably unfinished rather than deliberately nonfunctional.

Five of these vessels with hinged lids have been published.[9] Although the zoomorphic spout and handles are similar, the relief designs and the number of feet vary. One example, now in the British Museum, was "obtained out of the wall at the back of the king's compound" by Felix Roth during the 1897 punitive expedition (Roth [1903] 1968, 219). It is not known whether the vessel was put there to temporarily hide it or to serve a ritual function. Roth also mentions that the soldiers found large numbers of objects "embedded in the walls," and "occasionally" they found human bodies (Roth [1903] 1968, 217). Walls are used in Benin as temporary burial places (Nevadomsky 1984a, 42). It is not known if the objects found in the walls in 1897 were associated with such burials.

This vessel's motifs are all associated with death, particularly the oba's exclusive right to take human life. A python holding a human victim in its jaws forms the handle of the vessel. Its lethal crushing power, threatening even man, makes the python the "king" of snakes and the equivalent of the human oba (Ben-Amos 1976, 247). One of the oba's praise names is "Python of the Great Waters" (Ben-Amos 1980 symposium talk in Blackmun 1984, 409). The symbolic association between oba and python was also made by a giant copper-alloy snake that once extended down the turret of the palace roof.

The fanged, two-tailed beast whose jaws clench the spout is aggressive like the python and perhaps represents the leopard, the "king of the bush." But with its upright posture, obvious sexuality, and lack of spots, the beast differs significantly from other Benin representations of the leopard. The image is vaguely suggestive of a baboon, but baboons are uncommon in Benin iconography.

Around the middle of the vessel, the reliefs of bodiless heads with arms and legs represent Ofoe, messenger of Ogiuwu, god of death. Ofoe appears to people only at their death. In art, he appears primarily on the panels behind ancestral altars (fig. 5, left side, p. 19), on carved ivory tusks, and on con-

Detail of vessel.

temporary brass castings (Blackmun 1984, 260).[10] The god of death was never depicted in Benin art because, according to one carver, the oba acted as his symbol (Blackmun 1984, 260). The oba does appear on the lid of this vessel in a rare seated pose.

The oba alone decided whether a person would be put to death. In Benin, crimes such as treason were punishable by death. On certain ritual occasions, human sacrifices also occurred, but some sacrifices may have doubled as criminal executions.

Influenced by accounts of saintly martyrdoms and crucifixions, the practice of human sacrifice possibly began after European contact. Based on reports of foreign visitors, the practice seems to have increased with the kingdom's decline as a trading and military power. At the time of the punitive expedition in 1897, Benin frantically tried to avert the British military advance with human sacrifices. Thereafter, accounts of the expedition described Benin City as the "City of Blood" (Ryder 1969, 71, 247–50; Bacon 1897, 86–93).

Provenance
Augustus Lane-Fox Pitt-Rivers, before 1900
Pitt-Rivers estate, 1900–1965
Sotheby and Co., London, auction November 15, 1965
Joseph H. Hirshhorn, 1965–66

9. Similar examples are: British Museum, 1899 5–19.01 (Read and Dalton [1899] 1973, pl. 10, no. 1); Leipzig Museum für Völkerkunde (Luschan [1919] 1968, 417, fig. 643). Related examples are: Pitt-Rivers collection (Pitt-Rivers [1900] 1976, fig. 152); Berlin Museum für Völkerkunde III.C.8497 (Luschan [1919] 1968, pl.88).

10. A unique plaque is now in the collection of the National Museum, Benin City (Eyo 1977, 135).

7 FIGURE OF A FISH
Mid-16th century
Cast copper alloy, copper inlay
L. 6½ in. (16.5 cm)

Gift of Joseph H. Hirshhorn to the Smithsonian Institution
85-19-8

Along with leopards, crocodiles, snakes, and birds, fish are important symbolic animals in Benin art. Generally referred to in art literature as "mudfish," they are sometimes featured as the main subject on plaques, boxes, and stools[11] and are also found as subsidiary details on plaques, heads (cat. no. 3), and pendants (fig. 11, p. 57). This example is a unique three-dimensional figure.

This figure's straight body, barbels, gill rings, dorsal fin, and tri-lobed tail are typical features of Benin mudfish. Mudfish do, however, vary in pose (curved, straight, or skewered on a stick) and detail (number of fins or presence of barbels). They are artistic composites of several genera that have different physical and behavioral traits. Some possible models include the African lungfish (*Protopterus*), the walking catfish (*Clarias*), and the electric catfish (*Malapterurus*).

While this mudfish shares some physical characteristics with various genera, its scales differ significantly. The actual fish have small embedded scales, like the familiar catfish or eel, that are not easily visible. The artist of this example, fascinated by pattern, gave prominence to the scales with a scallop-and-dot treatment.

To the Edo, certain fish are appreciated because they taste good and are an appropriate sacrifice (Ben-Amos 1976, 245). In court art and legend, the prized characteristics are either protective or transformational. For example, fish with electric charges or poison spines symbolize the oba's aggressive powers (Gallagher 1983, 93). Fish that walk on dry land or survive long dry spells by burying themselves in muddy stream beds are, like the snake and crocodile, creatures of two worlds. They are symbols of Olokun, god of the great waters, and his human counterpart, the oba of Benin (Ben-Amos 1980, 46).

The artist who created this fish inlaid copper circled crosses. The pattern is associated with Olokun and occurs drawn in courtyards of Olokun shrines. It is possible that this fish figure was used in an Olokun shrine; the cast copper-alloy material probably indicates a royal owner. The circled-cross motif is called *aghadaghada*, a play on the Edo word *ada*, "crossroads." Like the foliate design with four lobes found on most plaques (cat. nos. 11–18), the circled cross simultaneously refers to the four directions, the four days of the Edo week, and the four major times of the day (Ben-Amos 1980, 28–29). It is best known as the background design on about twenty low-relief plaques. These plaques have been attributed to the same artist (Fagg 1963, no. 20) and placed at the beginning of plaque production in the early sixteenth century (Dark 1975, 59). Besides this fish, the only other three-dimensional figure employing the circled-cross motif is a leopard aquamanile in the British Museum (Ben-Amos 1980, pl. 83).

The relationship between god, divine oba, and symbolic fish is often shown in art by relief images of the oba with legs that are upward curving fish. In Benin today, this is commonly believed to depict Oba Ohen, an early ruler (c. 1430). He is reputed to have claimed that his sudden paralysis was not a physical imperfection making him ineligible to rule but a divine transformation (Blackmun 1984, 246, 248).

The Portuguese, who came by sea bringing wealth, are associated with Olokun and the oba, and therefore they are also linked with mudfish. Often artists juxtaposed images of mudfish and Portuguese on armlets, pendants, and plaques. Barbels, fins, and tails were depicted in the same manner as mustaches, beards, and hairstyles.

Provenance
Private collection, England, 1897[12]
Aaron Furman Gallery, New York, 1959
Joseph H. Hirshhorn, 1959–66

11. Outstanding examples are the cast copper-alloy fish-form container in the National Museum, Benin City, and the circular-based stool with a seat of intertwined fish in the National Museum, Lagos (Eyo 1977, 126, 149).

12. The original mount for this object has an engraved sterling silver plaque (not illustrated). As required for silver and gold articles by British law, the plaque is stamped with hallmarks. The hallmarks certify that the plaque is sterling silver and identify the manufacturer as Martin Hall and Co., Ltd. The plaque was assayed by the Sheffield Assay Office between July 1897 and July 1898 (the first Monday in July is the beginning of the hallmark year).

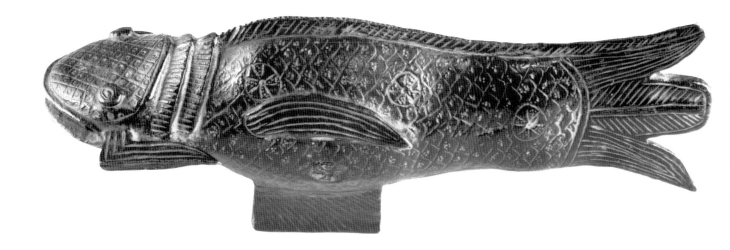

THE COURT

The Benin court, or more precisely the titleholders, served to balance the power of the oba. A consensus was needed to implement royal policies for the kingdom. In the complex court hierarchy, titleholders fulfilled a myriad of functions.[13]

The palace chiefs were the oba's intimate advisers. They headed three associations whose members performed as both government bureaucrats and domestic servants. The highest ranking association, Iwebo, cared for the royal regalia, supervised the craftsmen, and met with European traders. The Ibiwe association was responsible for the royal wives and children and for the provisioning of the palace. The Iweguae association held the household offices, those involving direct care or attendance on the oba. In addition to cooks and pages, it oversaw the ritual specialists who were concerned with the oba's health. The minor officials and guilds affiliated with the three palace associations included every specialized nonmilitary occupation from leopard hunters to metal casters. Entrance to a palace organization was hereditary, but most free men (except members of the royal family and certain religious specialists) were technically eligible to enter the ranks. Advancement required residence at the palace and the payment of fees.

The town chiefs, who lived on the opposite side of town from the palace, administered many of the kingdom's territories and villages. They supervised the collecting of tribute and the drafting of soldiers for the oba. Several war chiefs were among their number. They also represented the interests of their areas before the oba and the palace chiefs. Their positions were based less on heredity and more on personal achievement and politics. Some successful chiefs were able to increase their prestige by marrying sisters or daughters of the oba or by purchasing titles in palace associations for sons.

Another major court group was composed of the Uzama chiefs. They were considered to be descended from the chiefs or elders who put the ruling dynasty in power. Residing outside the inner walled

13. A full explanation of the workings of the Benin court, or even a listing of all the personages involved, is beyond the scope of this essay. This brief description is based on Bradbury (1973, 54–70) and Ben-Amos (1980, 6–7, 9).

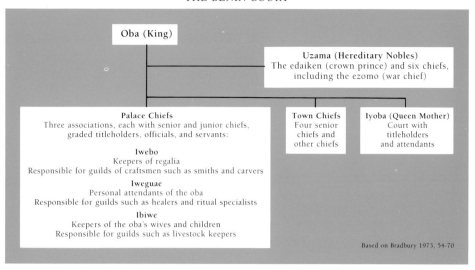

Based on Bradbury 1973, 54-70

city, these chiefs ruled their own territories. While always holding important ceremonial roles and exercising moral authority, their everyday political power varied over time. The ezomo, an Uzama chief, did exercise considerable power as one of the supreme war chiefs. The official heir to the crown, the edaiken, was also one of the Uzama. In theory, the oba's eldest legitimate son became the edaiken. The oba, however, did not have to formally install his heir, and because the oba had numerous wives, succession disputes sometimes arose (Bradbury 1973, 39). When appointed, the edaiken maintained his own court on the outskirts of the city at Uselu village.

Also residing in her own palace at Uselu was the *iyoba* (queen mother). Exercising royal powers over her assigned territory, the iyoba collected tribute, acted as a judge, and maintained a palace court with titled attendants. In Benin court protocol, the iyoba was the equal of a senior town chief. She was officially given her title about three years into her son's reign, following completion of the ritual ceremonies installing the oba. The custom of installing an iyoba is attributed to Oba Esigie and Iyoba Idia (c. 1506 or 1523). Before Iyoba Idia, according to oral tradition, the oba's mother was executed to prevent any rivalry with her son (Ben-Amos 1983, 79–80). After the practice ceased, the oba and the iyoba were prohibited from meeting directly. According to local and European accounts, living apart from the oba did not prevent an iyoba from having considerable influence in local politics, foreign affairs, and military campaigns.

Relations between the oba and his court, as well as within the levels of titleholders, were complex and fluid. Factors influencing power and status included heredity, talent, marriage to a royal relative, creation of new titles, and external political developments such as war or trade. Art objects served as a record of court life by depicting various costumed participants. Art also served as a indicator of relative status, particularly in the form of assigned items of regalia.

8 WARRIOR, FRAGMENT OF AN ALTARPIECE
18th–19th century
Cast copper alloy
H. 7½ in. (19.1 cm)
Gift of Joseph H. Hirshhorn to the Smithsonian Institution
85-19-21

This warrior figure was originally part of a rectangular altarpiece, known as an *aseberia*, that was placed on a memorial altar dedicated to an iyoba. On an aseberia, attendant figures such as warriors and bearers of ceremonial swords, staffs, and fans stand in procession along the sides and back of the base (fig. 8). The iyoba, the most important figure, is in the center at the back and is often larger in size. She is further distinguished by her extensive beadwork regalia and unique arched conical hairstyle. A hierarchical arrangement equating position, size, and regalia with an individual's relative importance is typical of court art and reflects the titleholding competition in the Benin kingdom.

This warrior figure differs from the attendants on the complete aseberia shown in figure 8 by being both male and clothed. Other similar male figures exist that are broken from their bases, including two identical to this figure in style and costume.[14] Several complete altarpieces with males in attendance are also documented.[15]

A possible explanation for the presence on aseberias of male figures in court regalia may be deduced from the relationship between the iyoba and her son. The iyoba and the oba never meet, but through messengers the iyoba offers advice. She advises not only as an ordinary parent but as one believed to have magical powers. She is, after all, the mother of a divine oba (Ben-Amos 1983, 82). The presence of a warrior on an altarpiece with an iyoba may refer specifically to help in battle. Idia, the mother of Oba Esigie and the first and most famous iyoba, commanded troops during her son's war with the Igala people of Idah in the early sixteenth century (discussed at cat. no. 9) and later helped subdue rebellious Edo chiefs in the town of Udo (Nevadomsky 1986, 44). In the early nineteenth century, Iyoba Omozogie, mother of Oba Osem-

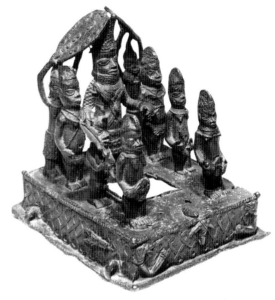

FIG. 8. *On this complete aseberia, an iyoba is surrounded by female attendants. H. 13 in. (33 cm). UCLA Museum of Cultural History. Photograph by Antonia Graeber.*

wede, was instrumental in the conquest of the Yoruba town of Akure (Egharevba 1960, 77).

The artist who created this warrior figure was fascinated with pattern, texture, and detail. The warrior wears a feather headdress, a leopardskin cloak, a collar of leopard's teeth, and a quadrangular bell (cat nos. 13–18; fig. 10, p. 42). The bell is of particular significance because its quadrangular shape is unique to Benin. Bells are still placed on ancestral memorial altars (fig. 5, p. 19), and soldiers once wore a smaller version. The soldiers' bells perhaps referred to those on the royal altars or to the shape of the palace roof turrets, providing a protective link to the ancestors (fig. 3, p. 15; Fraser 1972, 265). The sound of the bells challenged the enemy, identified comrades, and suggested unseen powers (Hess 1983, 105).

14. Berlin Museum für Völkerkunde, III.C.18154 (Luschan [1919] 1968, 327); British Museum, 1897 Ingram Gift (Read and Dalton [1899] 1973, pl. 11, no. 7).

15. Munich Museum für Völkerkunde (Luschan [1919] 1968, 316); Berlin Museum für Völkerkunde, III.C.8167, III.C.9949 (Luschan [1919] 1968, pls. 84, 85b).

Provenance
Augustus Lane-Fox Pitt-Rivers, before 1900
Pitt-Rivers estate, 1900–1966
Sotheby and Co., London, auction June 27, 1966
Joseph H. Hirshhorn, 1966–79

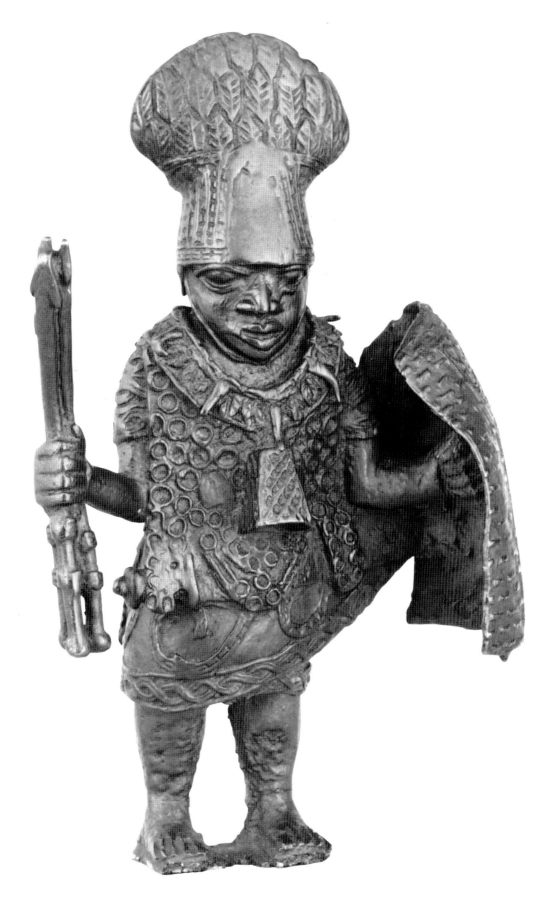

9 BIRD, FRAGMENT OF A GONG
18th–19th century
Cast copper alloy, iron rod
H. 6½ in. (16.5 cm)
Bequest of Eliot Elisofon
73-7-742

The Edo believe that birds are either messengers between the real and spirit worlds or transformed workers of magic. In Benin art, birds symbolize magical powers. They are often depicted with so-called medicine balls held in their beaks, another reference to magic (Ben-Amos personal communication in Curnow 1983, 222).[16]

This bird was originally cast atop a cylindrical tube that was probably about seven inches long. The tube was held in one hand while the bird was struck on the beak with a metal rod. The bird, therefore, is a type of musical instrument known as an idiophone; it is commonly referred to as a gong. But more significant is its symbolic function. Bird gongs are used by chiefs during the Ugie Oro festival, which commemorates the sixteenth-century victory of Oba Esigie over the leader of the Igala people, the *ata* of Idah.

Oba Esigie did not just defeat an external foe, according to an often-told story, he overcame the doubts of his people and the inevitability of fate itself. As Esigie led his army from Benin City, a bird flew overhead and cried of disaster. Esigie did not succumb to the panic of his troops or the warnings of his advisers. He ordered the bird killed, and Benin went on to win the war. (In one version, Portuguese soldiers aiding the oba killed the bird (Nevadomsky 1986, 44).) Esigie began the casting of bird-form idiophones to remind the court that a divine oba succeeds where ordinary people fail. The bird gongs reinforce the hierarchy of oba over chiefs.

The type of bird depicted is problematic. Although an early publication calls the bird a vulture (Read and Dalton [1899] 1973, 12), most subsequent books and catalogues identify it as an ibis (e.g., Luschan [1919] 1968, 269). The term *ibis*, however, should be considered a foreign generic label for a long-beaked, long-legged bird. Recent fieldwork has identified the oracular bird as a short-beaked West African species (Nevadomsky 1986, 44). The bird has also been tentatively identified as a kingfisher (Ben-Amos 1976, 252). The beaks of cast birds may be intentionally exaggerated to symbolize the power of spoken prophesy (Nevadomsky 1986, 44). Alternatively, cast birds may differ in appearance from real birds because the cast birds are composite representations.

16. *Medicine* is a generic term for any substance with protective or curative properties based on magic and divination, although strictly pharmaceutical aspects of herbalism may also be present.

Provenance
Ladislas Segy, New York, 1949
Eliot Elisofon, 1949–73

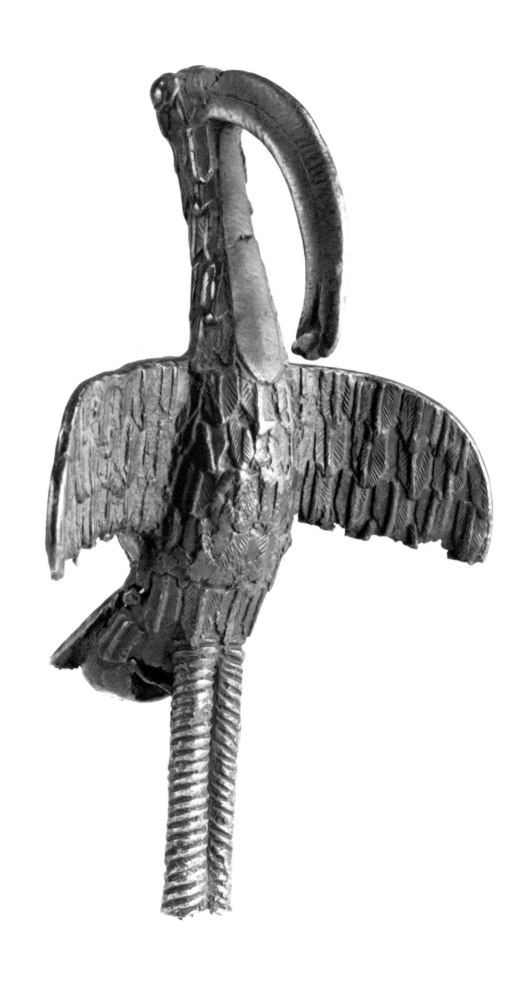

10 CYLINDRICAL OBJECT
18th–19th century
Cast copper alloy
H. 9⅝ in. (24.5 cm)
Gift of Joseph H. Hirshhorn to the Smithsonian Institution
85-19-11

The function of this cylindrical object with four female figures is uncertain. Female images in Benin court art immediately suggest an association with the iyoba, the only politically significant woman. There are only two other published examples of this type of object. They are virtually identical to this one in size, style, and iconography, suggesting that this type of object may have been produced only for a brief time (Pitt-Rivers [1900] 1976, fig. 139; Luschan [1919] 1968, pl. 110).

Three factors restrict our knowledge of iyoba-related objects. First, the iyoba's palace was deliberately burned in 1897 by the British as "one more of the headcentres of vice in the city" (Bacon 1897, 105). Secondly, although Eweka II was allowed by the British to assume the kingship in 1914, he was not permitted to install an iyoba. The title was given posthumously in 1933 (Egharevba 1960, 78), a considerable lapse of time in court ceremonies connected with an iyoba. Finally, the rituals held by the oba to commemorate the iyoba are private, not state, affairs (Ben-Amos 1983, 82).

The netted beadwork costumes and the jewelry worn by these female figures playing musical instruments suggest either regalia awarded to persons of rank or special ceremonial dress rather than the ordinary clothing of court musicians. The single triangular gongs played by two of the women are conventional musical instruments, but the bird gongs held by the other two are not. Bird gongs are struck by male chiefs to recall the sixteenth-century military triumph of Oba Esigie despite an unfavorable omen (cat. no. 9). A woman with a bird gong may refer to Idia, Esigie's mother, who actively participated in the war. The first woman in Benin history to lead troops into battle, Idia used her magical powers to create strong protective charms for the soldiers. Her courage in pursuit of the retreating enemy inspired comparison with the oba's courage (Nevadomsky 1986, 44). Further, the bird gongs on this object, like the bird gongs used by male chiefs, perhaps are also symbols of the oba's supremacy in the court hierarchy.

Some explanations regarding the function of this type of object concentrate on the hollow cylindrical form. Pitt-Rivers identified the object in his collection as a holder for a carved ivory tusk ([1900] 1976, 46). The Museum für Völkerkunde und Vorgeschichte in Hamburg considered its piece to be a base for a large copper-alloy staff with male figures (Luschan [1919] 1968, 320–21). The twenty-pound weight of this example, much less than either an ivory tusk or a copper-alloy staff, makes both identifications questionable.

This type of object has also been classified as an *ikegobo,* "altar of the hand," specifically for the iyoba (Dark 1982, fig. 16a; Kaplan 1981, 32). Ikegobos are dedicated to personal achievements, those things literally and figuratively obtained through the work of one's hands. Although ikegobos are commonly made of wood, a few copper-alloy examples exist that were individually owned by an oba, an honored war chief, and an iyoba (Bradbury 1973, 253). Male-owned ikegobos feature symbols of power, war, and sacrifice. The versions thought to belong to iyobas have a hierarchical scene of an iyoba flanked by attendants. These features are notably absent from the cylindrical objects with musicians. While a carved tusk or figurative staff placed in a cylinder's top may have provided the missing hierarchical focus, it is likely that this type of object was intended for a subsidiary role on an altar, not for center stage.

Provenance
Dr. J. P. Howe, 1897–1934
Sotheby and Co., London, auction November 20, 1961
 (property of Capt. J. S. Howe, 1934–61)
Joseph H. Hirshhorn, 1961–66

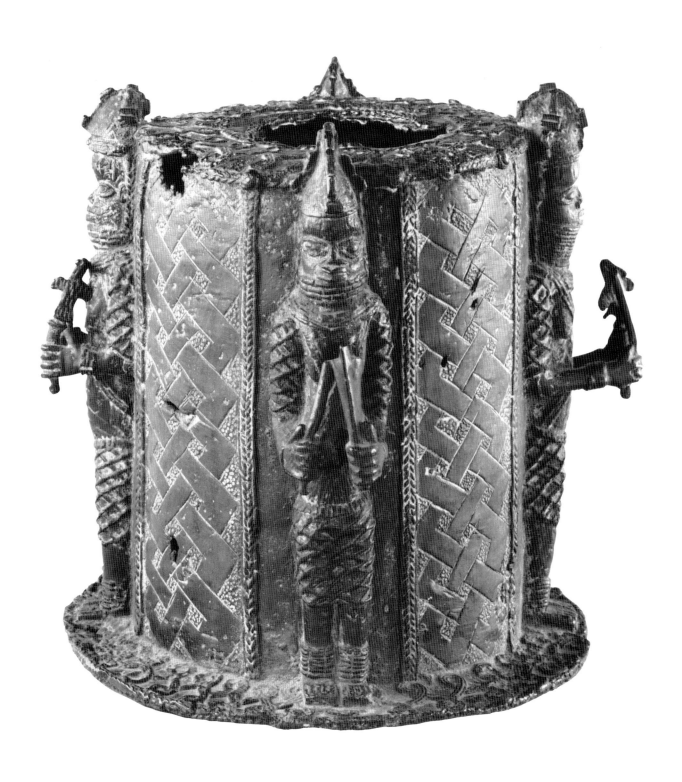

PALACE PLAQUES

Approximately nine hundred plaques still exist in public and private collections. Allowing for damage, all are rectangular in shape and relatively uniform in height. They are cast copper alloy, probably brass, and depict discrete scenes in low to high relief. The majority have stippled backgrounds with foliate designs. The four-lobed foliate design—variations in the number of lobes do occur on the plaques—is described as *ebe ame,* "river leaves," a reference to Olokun, god of the sea. Relief rosettes on some plaques represent the sun and, since the sun sets in the sea, are also thought to be associated with Olokun (cat. nos. 11, 15, 16) (Ben-Amos 1980, 28–29). References to Olokun on objects intended for the oba's palace are particularly appropriate because royal wealth increased considerably with overseas trade.

Holes were punched in the plaques to attach them with nails to palace walls or pillars. (Some collectors drilled holes in the plaques for exhibit mounts.) In 1897 when the British punitive expedition removed the plaques from Benin City, they were not installed on pillars but were "buried in the dirt of ages, in one house" (Bacon 1897, 91). Most likely, the plaques were not literally buried but instead were stored in the house; according to one chief, a pre-1897 palace attendant, the plaques were consulted on questions of court procedure (Willett 1985, 105). The plaques were first mentioned in a seventeenth-century book by Olfert Dapper that compiled earlier accounts by Dutch visitors to Benin City. In his book, the palace was described as being composed of "beautiful and long square galleries about as large as the Exchange at Amsterdam, but one larger than another, resting on wooden pillars, from top to bottom covered with cast copper on which are engraved pictures of their war exploits and battles, and are kept very clean" (translated in Roth [1903] 1968, 160). There are some discrepancies between the surviving plaques and the cast copper on the pillars described in Dapper's book. The plaques are individual rectangles of copper alloy and are cast in relief, not engraved. Although some plaques do show battles and other scenes suggestive of a narrative, such as sacrifices and hunts, others depict symbolic animals, such as crocodiles, pythons, mudfish, and predatory birds. Many show one or two isolated male figures posed in court regalia (cat. nos. 11–16). Multifigure plaques often combine the same personages found on single- and double-figure plaques (cat. nos. 17–18).

As originally arranged, it is possible that the plaques conveyed hierarchical groupings or even specific ceremonies in the royal court's ritual calendar. For example, a number of plaques, including plaque number 11, show a man holding what appears to be a bead-covered gourd rattle. At the installation of new titleholders by the edaiken in 1978, it was the only musical instrument permitted to the participants (Nevadomsky and Inneh 1983, 53). Perhaps an equally distinctive occasion would have been represented by a group of plaques.

Some items of costume and regalia seen on the plaques can be identified from surviving court practices, actual objects, and historical records. For example, the figures on a number of plaques hold ebens, fanlike ceremonial swords, in their right hands (cat. nos. 14–15). As a gesture of respect to the oba in court ceremonies, the open-worked eben is held aloft, spun rapidly, and touched to the ground. In a 1958 Igue ceremony, dedicated to promoting the well-being of the reigning oba, a senior chief saluted the oba with his eben in the same way as the titleholders seen on the plaques (fig. 9). An eben also functions as a sign of rank and may be carried by attendants of important personages (cat. nos. 17–18). Other items, such as the leopardskin shoulder bags in plaque number 12, have been lost in time.

On a multifigure plaque, a representation of an attendant or a comparatively lower-status person is smaller in size or has less regalia than the central figure; some attendants are even shown nude (cat. nos. 17–18). The incised decorations on the nude figures probably represent impermanent body paint rather than the Edo scarification of vertical lines that is seen on the bare torsos of other figures (cat. nos. 11–12, 14).

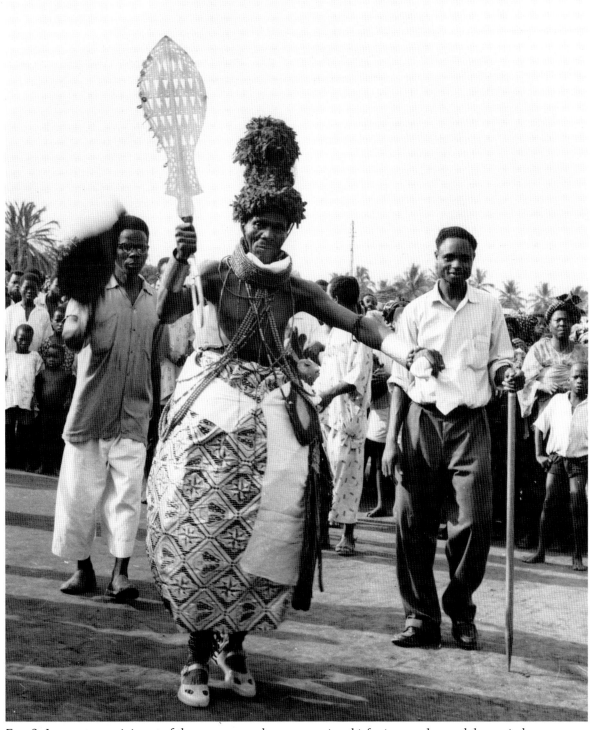

FIG. 9. *In a scene reminiscent of those on many plaques, a senior chief raises an eben and dances in honor of the oba at the Igue ceremony. Photograph by W. B. Fagg, 1958.*

Regalia, including costume, was in general a sign of rank and position and was assigned to a titleholder by the oba. Items were given either for a specific ceremony or for the titleholder's lifetime. The plaques are records of the variety of court regalia in Benin. Plaques number 14 and number 15 show men wearing cast copper-alloy hip ornaments in the form of human faces (cf. fig. 11, p. 57). All chiefs wear pendant masks on their left hips as part of their full ceremonial regalia (Ben-Amos 1980, 75). The high beaded collars, wide armlets, and high anklets with rattles seem to be generic symbols of high status (cat. nos. 11, 14, 17–18). They are found on other objects and are in use today (cat. nos. 4, 10; fig. 4, p. 17; fig. 9, p. 41). Men's wrappers depict a variety of locally woven cotton and raffia cloth, as well as European and Indian imported cloth; the men in plaque number 12, for example, wear imported red flannel cut to resemble pangolin skin (the identification is based on contemporary court costumes). The end of a garment sometimes extends upward behind a figure's shoulder in what may be an artistic exaggeration of a clothing style (cat. nos. 11–12). Leopard's-face tunics and quadrangular bells suggest aggressive or military powers (cat. nos. 16–18). Quadrangular bells, which hung from pectoral bands containing amulets of magical protective substances, probably were used to protect warriors in battle (cat. no. 8; fig. 10) (Ben-Amos, 1980, 60). Horsetail headdresses symbolized military authority and were worn by war chiefs, according to Dapper (cat. no. 13) (Ryder 1969, 40). Benin imported the horsetails, which are listed on early European trade manifests (Ryder 1969, 40). As shown on the plaques, the flared horsetail headdresses resemble depictions of the Portuguese hairstyle, perhaps a deliberate reference to the traders who brought power and wealth—guns and trade goods—to the kingdom (cf. cat. nos. 17–18).

Portuguese and other Europeans can be identified on plaques by their prominent aquiline noses, long hair, and European dress. They are the primary characters on some plaques, and they appear as supplementary figures on others. An incised Portuguese

FIG. 10. *This bell was once placed on an ancestral altar. As depicted on the plaques, warriors wore smaller bells. H. 8¼ in. (21 cm). Gift of Joseph H. Hirshhorn to the Smithsonian Institution. National Museum of African Art, 85-19-22.*

head is a pattern detail on two men's wrappers (cat. nos. 11, 18). More easily seen half figures appear on two other plaques (cat. nos. 17–18). It is not clear whether the half figures are simply artistic inventions by the caster or whether they are protective (see cat. no. 19) or status symbols. It is likely that they are symbols of status because one figure holds a manilla, the C-shaped metal ingot used as trade currency (cat. no. 18, upper left), and two hold unidentified squares, possibly mirrors or other trade items (cat. no. 17). On a third virtually identical plaque in the Berlin Museum für Völkerkunde, the Portuguese appear to be drinking from two-handled flasks and holding manillas (III.C.7657; Luschan [1919] 1968, pl. 23).

The inclusion on plaques of Europeans and imported trade items means that they were created after 1486, the year the kingdom first had contact

with the Portuguese; however, there is not a firm chronology for the corpus of extant plaques. The increased availability of previously scarce copper and brass after contact with the Portuguese is often cited to explain the increase in Benin artistic production of metal objects such as plaques. Even the plaque form, it is theorized, may have been influenced by the design of European books and engraved pictures or by Indian caskets with relief panels (Forman, Forman, and Dark 1960, 24; Dark 1973, 4).[17] In an account recorded in 1897, the Benin court historian, the master priest, and others trace the beginning of plaque making to the mid-sixteenth century, when Oba Esigie put an image of a captured king "in brass . . . nailed . . . to the wall of the house." The court members did not provide any information about when plaque production ceased; they did say they could not identify those represented on the plaques (Read and Dalton [1899] 1973, 4, 6).

Proposed chronologies, including the widely used chronologies of Fagg and Dark, rely on a theory of style development from simple to complex (classic to baroque) and from low to high relief. Dating in this sequence is also keyed to European accounts. By about 1640, the probable date of the description of the oba's palace cited by Dapper, the plaques were in place on the palace pillars; by about 1700, production had supposedly ceased. The proposed date for the end of plaque production is based on a 1702 letter from Dutchman David van Nyendael to author-traveler William Bosman that does not mention the plaques but does mention extensive thunderstorm damage to the palace (Bosman [1705] 1967, 463). It has also been suggested that the majority of plaques may have been made during a much shorter period of time before 1640 (Dark 1975; Tunis 1983). Thermoluminescence tests give some support to the theory, although most of the plaques have not yet been tested (see Shaw 1978; Tunis 1983).

17. Portuguese cargoes to Benin were not limited to items from Portugal. They included trade goods from India, notably cloth, as well as goods from other European countries.

Provenance

Catalogue number 11:
British government (collected by Sir Ralph Moor, commissioner and consul general of the Niger Coast Protectorate, on behalf of principal secretary of state for foreign affairs) 1897–98
British Museum, 1898
Alfred Brod Gallery, London
Margaret Gardiner
Harold Diamond, New York, 1959
Joseph H. Hirshhorn, 1959–66

Catalogue number 12:
Augustus Lane-Fox Pitt-Rivers, before 1900
Pitt-Rivers estate, 1900–1965
Sotheby and Co., London, auction November 15, 1965
Joseph H. Hirshhorn, 1965–66

Catalogue number 13:
Augustus Lane-Fox Pitt-Rivers, before 1900
Pitt-Rivers estate, 1900
Aaron Furman Gallery, New York, 1959
Joseph H. Hirshhorn, 1959–66

Catalogue number 14:
Galerie (Henri) Kamer, Paris, 1968
Joseph H. Hirshhorn, 1968–79

Catalogue number 15:
Sotheby and Co., London, auction November 20, 1967 (property of Mrs. D. H. Walker)
Joseph H. Hirshhorn, 1967–79

Catalogue number 16:
Duveen-Graham Gallery, New York, 1957
Joseph H. Hirshhorn, 1957–66

Catalogue number 17:
Augustus Lane-Fox Pitt-Rivers, before 1900
Pitt-Rivers estate, 1900
Private collection, New York, before 1982

Catalogue number 18:
H. Meyer, c. 1919
Galerie (Henri) Kamer, Paris, 1968
Joseph H. Hirshhorn, 1968–79

11 PLAQUE: MAN WITH RATTLE
Mid-16th–17th century
Cast copper alloy
H. 17⅛ in. (43.5 cm)
Gift of Joseph H. Hirshhorn to the Smithsonian Institution
85-19-4

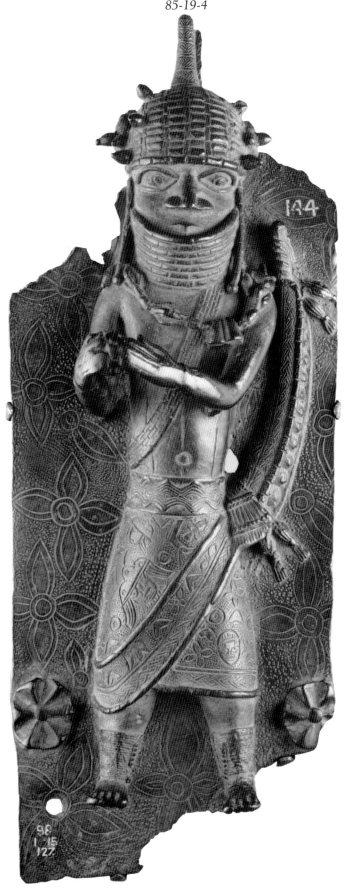

12 PLAQUE: MEN WITH LEOPARDSKIN BAGS
Mid-16th–17th century
Cast copper alloy
H. 18½ in. (47 cm)
Gift of Joseph H. Hirshhorn to the Smithsonian Institution
85-19-13

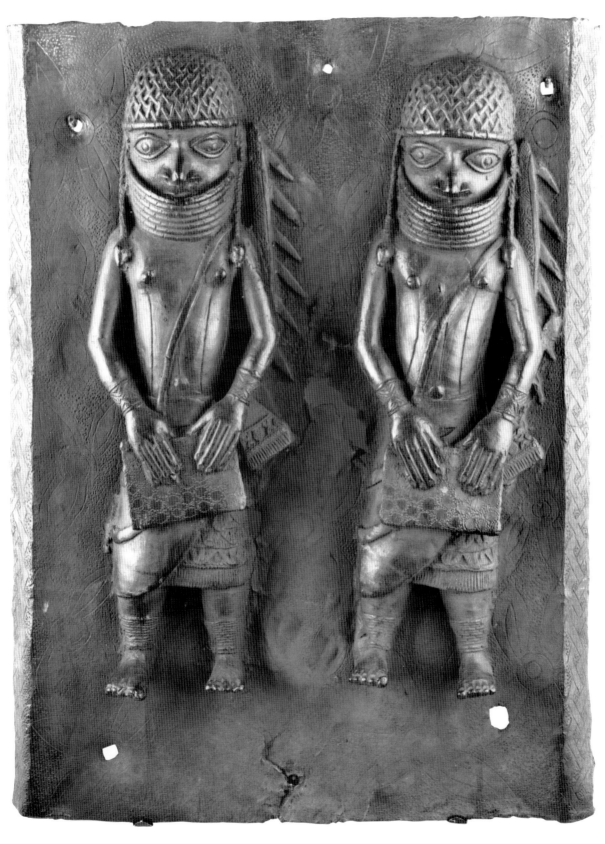

13 PLAQUE: BOWMEN
Mid-16th–17th century
Cast copper alloy
H. 13½ in. (34.3 cm)
Gift of Joseph H. Hirshhorn to the Smithsonian Institution
85-19-6

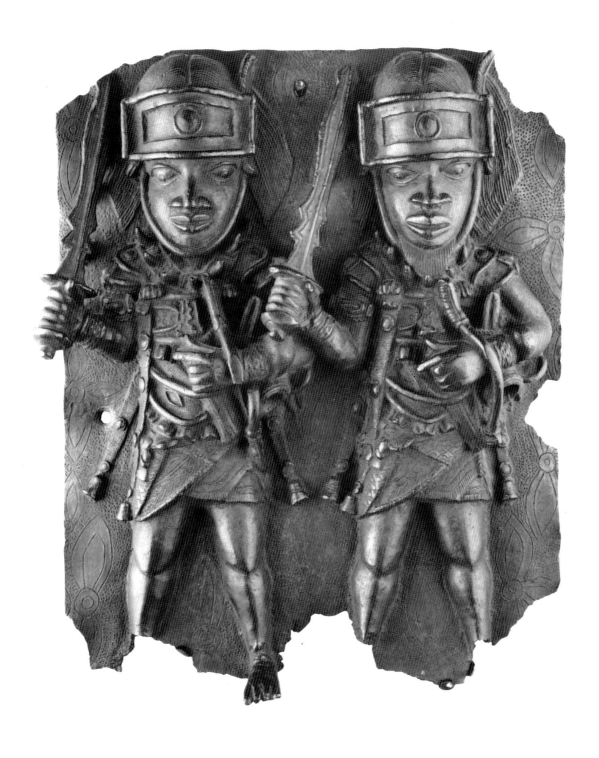

14 PLAQUE: MAN WITH EBEN
Mid-16th–17th century
Cast copper alloy
H. 17⅜ in. (44.1 cm)

Gift of Joseph H. Hirshhorn to the Smithsonian Institution
85-19-20

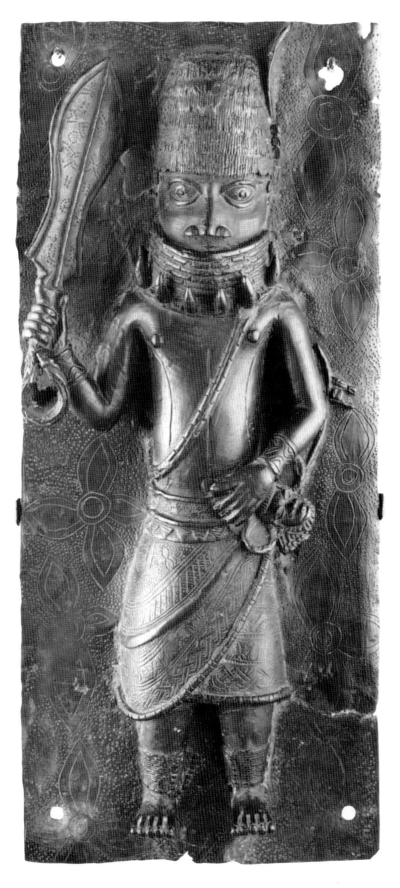

15 PLAQUE: MAN WITH EBEN
Mid-16th–17th century
Cast copper alloy
H. 18⅜ in. (46. 7 cm)
Gift of Joseph H. Hirshhorn to the Smithsonian Institution
85-19-19

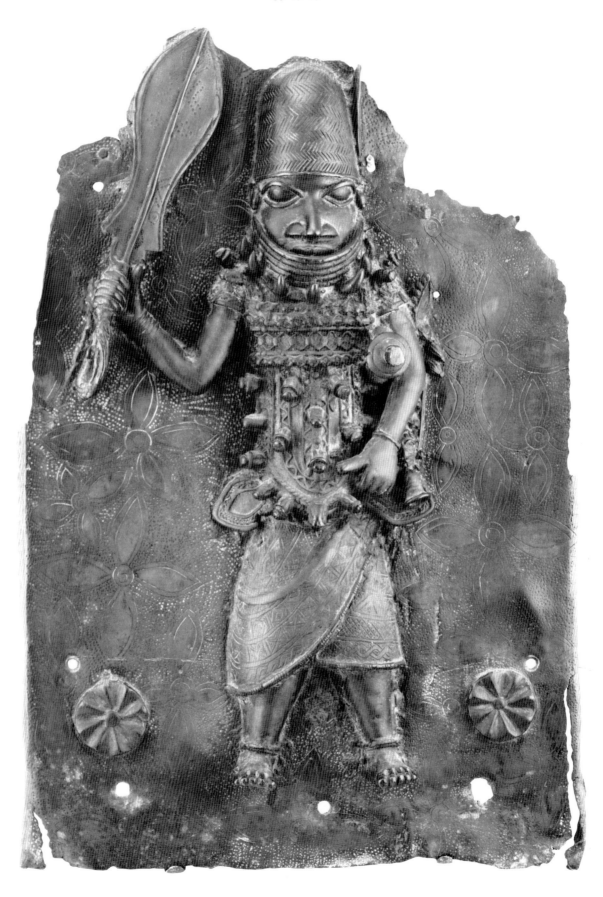

16 PLAQUE: MAN WITH EBEN
Mid-16th–17th century
Cast copper alloy
H. 17 in. (43.2 cm)
Gift of Joseph H. Hirshhorn to the Smithsonian Institution
85-19-2

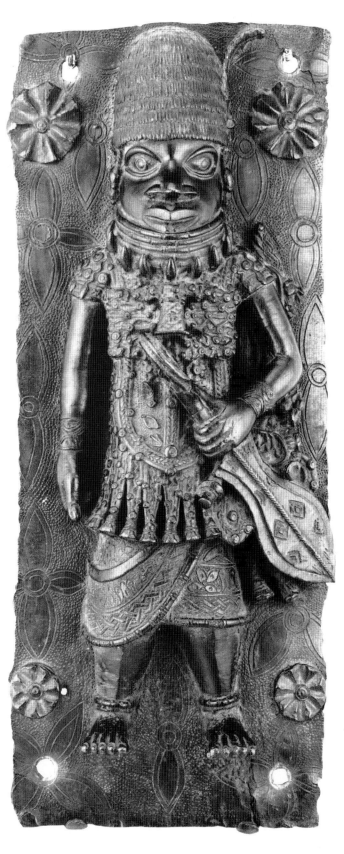

17 PLAQUE: MULTIPLE FIGURES
Mid-16th–17th century
Cast copper alloy
H. 18 in. (45.7 cm)
Purchased with funds provided by the Smithsonian Institution Collection Acquisition Program, 1982
82-5-3

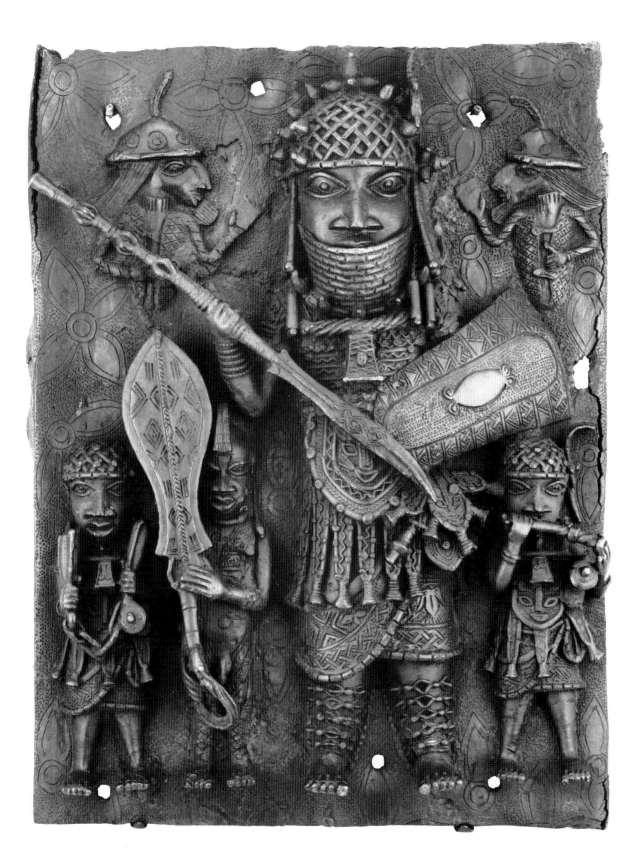

18 PLAQUE: MULTIPLE FIGURES
Mid-16th–17th century
Cast copper alloy
H. 19¼ in. (48.9 cm)

Gift of Joseph H. Hirshhorn to the Smithsonian Institution
85-19-18

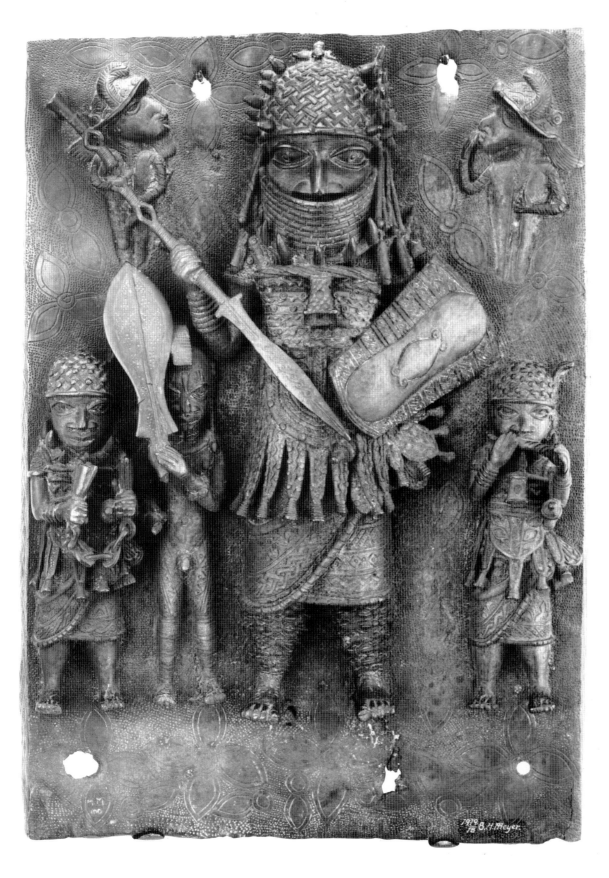

FOREIGNERS

The Benin oba and court, and the art associated with them, did not exist in isolation. Oral tradition tells of interactions with the Yoruba people to the west, the Nupe people to the north, the Igala to the east, and the Igbo people and other groups to the southeast. Art objects provide a record of foreign contacts. Africans who are not Edo are identifiable by differences in scarification and costume. Some of them are obviously captive or dead soldiers. The status of others is uncertain; they are perhaps messengers or defeated kings (cat. no. 1). Other relationships, particularly with Yoruba art, are more subtle and complex. Some iconographic symbols, such as the mudfish (cat. no. 7) and the bird (cat. no. 9), are common to both Yoruba and Benin art. In addition, ivory and copper-alloy objects in the styles of Owo and Ife, two famous Yoruba cities, have been found in Benin City (Eyo 1977, 97–98). There is continuing study and debate about Ife and the origin of lost-wax casting in Benin (discussed at cat. nos. 1–3).

The influence of non-Edo African cultures is of importance as background for understanding the manner in which European visitors and artifacts were assimilated into Benin art. The Portuguese were the first Europeans to contact Benin. In 1486, Portugal's King John II sent João Afonso d'Aveiro to explore inland on the rivers near Benin. Portuguese trade, based primarily in the riverside village of Ughoton, continued until the early 1550s with some competition from the French. By the end of the sixteenth century, the Dutch dominated the market, and there was also a small English presence (Ryder 1969, 24–84).

The early days of trade essentially saw Africans and Europeans dealing as equals. The Europeans were in general favorably impressed with the size of Benin City and the power of the oba. Delegations from Benin were sent to Portugal. Benin court officials who super-

vised the international trade spoke Portuguese even after other nationalities became the dominant traders (Ryder 1969, 130). The Europeans wanted West Africa's Guinea pepper, or "grains of paradise," which was competitive in price and comparable in taste with Indian pepper. They also wanted ivory. Slaves, cloth, and stone beads were shipped by the Portuguese from Benin to the Elmina trading fort on the Gold Coast, where they were then traded for gold (Ryder 1969, 37). In return, Benin received European and Indian cloth, cowrie shells, brass, hats, coral and glass beads, and other nonutilitarian goods. Luxury items such as mirrors and telescopes were sent from Europe as gifts for officials of the Benin court. In the late sixteenth century, the Dutch began trading utilitarian items such as pots and pans, and in the seventeenth century, they shipped a wide range of goods, including guns (cat. no. 19; Ryder 1969, 95).

Commerce had direct impact on Benin art. The most obvious development was the depiction of Europeans on a number of Benin art objects, such as plaques and pendants (cat. nos. 17–18, 20). Long-haired Europeans appear as incised decorative details on many pieces that seem completely Edo in subject matter (cat. no. 11). Certain trade items—hats, cloth, beads—were integrated into court regalia. Foreign trade introduced new types of objects and influenced others. Hinged-lid vessels with feet (cat. no. 6) and architectural plaques possibly developed from foreign prototypes. Europeans also commissioned ivory saltcellars and spoons (cat. no. 21) for their own use. The most fundamental effect of European trade was the dramatic increase in cast copper-alloy objects due to the increased supply of imported copper and brass. Not only were there numerically more items such as plaques, but other cast objects such as commemorative heads became larger and heavier.

19 EDO MUSKETEER FIGURE
19th century
Cast copper alloy, iron rods
H. 20¼ in. (51.4 cm)
Gift of Joseph H. Hirshhorn to the Smithsonian Institution
85-19-15

This figure was probably intended for use on a royal ancestral altar for a past oba. The metal projections below the rectangular base appear to be unremoved casting sprues, suggesting that this piece was never finished. An early report on an identical figure in the Liverpool Museum, however, describes it as being "found in a Juju house in the King's compound" (Forbes 1898, 54).[18] Both pieces, therefore, may have been used. If so, the peculiar base is an intentional feature.

This figure, a member of the Benin court, is dressed in a combination of local and European-influenced regalia. The forehead and torso scarification marks indicate that the figure is an Edo. Although details vary, the pose and the costume relate to presumably earlier figures of Portuguese musketeers.[19] Instead of elaborately chased European armor, this figure wears a leopardskin tunic. The pleated skirtlike garment, though not found on three-dimensional sculptures of Portuguese musketeers, is like those worn by Portuguese in relief representations on a number of plaques and pendants (e.g., Luschan [1919] 1968, figs. 577–78, pls. 1–6).

Because this figure holds a gun and is similar to Portuguese figures, it probably represents a member of the Iwoki guild, which looked after the royal guns and cannons. The Iwoki trace their origin to the sixteenth-century reign of Oba Esigie and to two Europeans called Ava and Uti. The two are said to have once protected the oba by flanking him with their guns, a practice continued today by Iwoki members on certain ceremonial occasions (Bradbury 1973, 35–36). Portuguese accounts from 1516 do report that Duarte Pires and João Sobrino, two Portuguese living in Benin possibly as trade representatives, accompanied an oba on a war campaign, but no mention is made of their protecting the oba (Ryder 1969, 49).

The sixteenth-century Portuguese for the most part abided by a papal ban on the sale of firearms to non-Christians. King Manuel I of Portugal (1469–1521) specifically wrote in 1514 that arms sales were linked to conversion (Ryder 1969, 47). Benin artists, nonetheless, were familiar with Portuguese guns. At least one figure of a Portuguese soldier holds an early matchlock musket with a distinctive serpentine lever.[20] In the 1690s, the Dutch in Benin began selling the flintlocks that most musketeer figures hold (Ryder 1969, 145). The nine round balls on this sculpture's base may be the shot used for either type of musket.

A decapitated human head—a war trophy—is also on the base. The head has three vertical scarification marks over each eyebrow, which usually denotes a local Edo rather than a foreigner. This may relate to the Iron ceremony. It is a mock battle in which the oba's opponents are the Uzama, the seven original chiefs who brought the dynasty of the obas to power (Ben-Amos 1980, 85). In the ceremony, the Iwoki guard the oba. Despite the ideal of divine kingship, Benin history includes a number of succession disputes, civil wars, and minor rebellions. The mock battle, like the trophy head on this figure's base, symbolizes the oba's eventual victory.

The oba controlled foreign trade. While guns were desired imports, the trade currency was often the manilla, a C-shaped metal ingot that came in a range of sizes and weights. The braceletlike form on the base by the figure's right heel is a variant of the standard shape. At first made of copper, most manillas were later made of brass. They were melted for use in art objects or worn as regalia. In 1517, a single ship brought thirteen thousand manillas to Benin. Forty-five manillas were traded for an eighty-pound tusk and fifty-seven for a slave (Ryder 1969, 40, 53).

Provenance
Augustus Lane-Fox Pitt-Rivers, before 1900
Pitt-Rivers estate, 1900–1965
Sotheby and Co., London, auction November 15, 1965
Joseph H. Hirshhorn, 1965–66

18. The term *juju* is West African in origin. It usually refers to a charm or an amulet, but in this context it probably refers to a shrine.
19. Approximately twelve survive: British Museum; Berlin Museum für Völkerkunde; Dresden Museum für Völkerkunde; National Museum, Lagos; and various private collections (see Dark 1982, 2.4.4).
20. British Museum, 1928.Af 1–12.1 (Ben-Amos 1980, fig. 26).

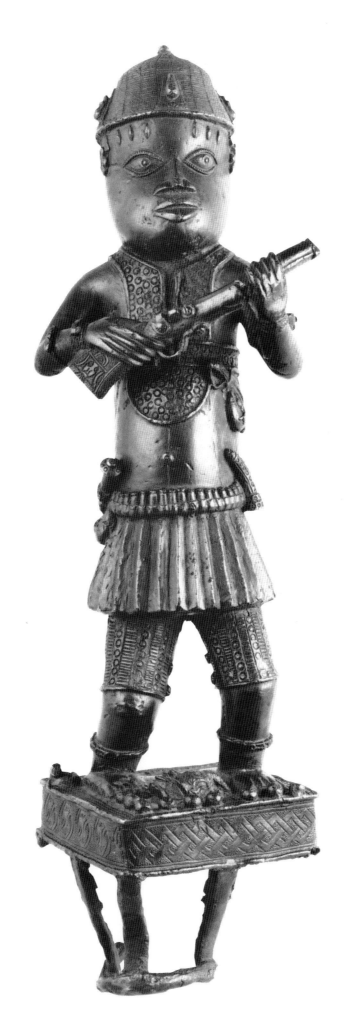

20 PENDANT WITH EUROPEAN AND HORSE
18th–19th century
Cast copper alloy
H. 8 in. (20.3 cm)
Gift of Joseph H. Hirshhorn to the Smithsonian Institution
85-19-9

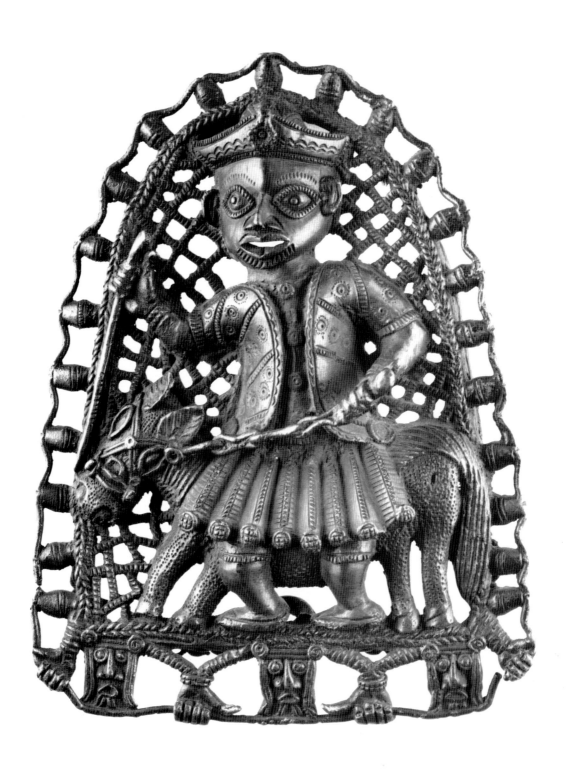

Brief surveys of Benin art often tend to stress the standard and traditional. Benin artists also had the opportunity to create new objects and rework traditional themes.

This pendant depicting a European with a horse is unusual in several ways. Its half-oval shape points upward, the opposite of typical semicircular pendants (cat. no. 5). The netlike open-worked background differs from the backgrounds of other semicircular pendants, although it is reminiscent of the headdresses depicted on pendant masks (fig. 11). The projecting border around the edges and the two fastening loops on the back are likewise similar in design to pendant masks rather than other semicircular pendants. While the man's pleated garment resembles European dress shown on Benin plaques and ivories,[21] his short hair differs from the shoulder-length style favored in depicting Europeans (cat. nos. 17–18); the somewhat abstracted faces along the pendant's bottom border do have long hair. Finally, the man stands beside the horse, neither riding astride like a foreigner nor sidesaddle like a Benin oba or noble (D.R. 1602 in Hodgkin 1960, 121). In depictions of both riding styles on plaques, the riders' feet clear the ground.

The horse has a long history as a symbol of wealth and power in Benin. It is likely that even before contact with Europeans, the Edo were familiar with horses and understood their military significance. They were aware that to the north the powerful Islamic states ruled the savanna with fearsome cavalries. But horses did not live long in the forest region where Benin was located, succumbing to the disease nagana carried by tsetse flies. When Europeans came to the kingdom, they brought horses. The great care that horses required in Benin only increased the prestige of owning them. King Manuel I of Portugal gave the oba a caparisoned horse in 1505 (Ryder 1969, 41). A 1602 Dutch account implies that Benin was importing horses (Ryder 1969, 85); additional accounts document the importation of horsetails for use in regalia (Ryder 1969, 40, 79–80; cat. no. 13). By the eighteenth century, the oba was lending horses to Dutch and French trade representatives (Ryder 1969, 181, 200–201).

The pendant's border is a combination of additional symbols of wealth and power. Like the horse, they attest to the importance of foreign trade to

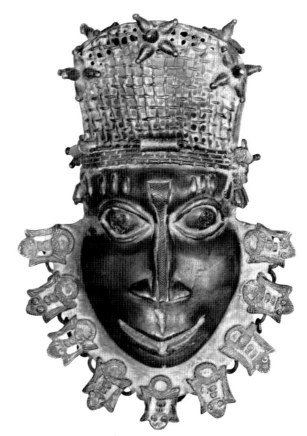

FIG. 11. *This pendant features an open-worked headdress and a collar of separately cast mythical fish. H. 8½ in. (21.6 cm). Gift of Joseph H. Hirshhorn to the Smithsonian Institution. National Museum of African Art, 85-19-5.*

Benin. The closed fist with upraised thumb is associated with the "gathering up of riches" (Ben-Amos 1980, 57). It is often found on altarpieces and carved ivory tusks. The Portuguese face refers to the wealth that came by sea and, therefore, to Olokun, god of the sea. The barrel-like form is probably a symbol of Olokun as well. The form, also depicted on carved tusks, has three possible meanings, all of which may overlap (Blackmun 1984, 433–34). It may represent a barrel of gunpowder, needed for the imported royal guns. It may refer to a piece of white chalk used by an Olokun devotee in various ritual contexts. Finally, the form may represent one of the ubiquitous red beads of Benin regalia, specifically a speckled red stone bead that is considered to be the oldest variety. Red stone beads, according to legend, were part of the treasure obtained by Oba Ewuare (c. 1440) in a trip to Olokun's palace.

Provenance
Aaron Furman Gallery, New York, 1959
Joseph H. Hirshhorn, 1959–66

21. This figure's pleated garment is also similar to the European-influenced ceremonial garment of the Edo musketeer (cat. no. 19).

21 Spoon
16th–17th century
Ivory
H. 6½ in. (16.5 cm)
Bequest of Mrs. Robert Woods Bliss
69-20-4

In 1588, James Welsh, the chief master of the English merchant ship *Richard of Arundell,* visited the city of Benin. He reported that the people made "spoones of elephants teeth very curiously wrought with divers proportions of foules and beasts made upon them" (Hodgkin 1960, 117). Garcia Mendes Castel Branco found in 1621 that the spoons were still being made by local people (Curnow 1983, 164). The spoons referred to in both accounts were probably similar to this spoon, one of only two in the United States and about forty-five in the world.

Ivory spoons, along with ivory saltcellars and hunting horns, were made for export. Using local techniques and applying high standards of craftsmanship, Edo artists created new objects and motifs at the request of foreign patrons. To distinguish these export objects from traditional ivories made for the oba, such as bracelets, pendants, musical instruments, and memorial altar tusks, the terms *Bini-Portuguese* and *Afro-Portuguese* are used in the art literature.

A great variety of figural motifs appear on the stems of the spoons. Carved either alone or in combination, for example, are antelopes, crocodiles, dogs, fish, monkeys, pangolins, and pythons. The only human representations are a single Portuguese man and an isolated human hand. The bird is a common image, found on about fourteen surviving examples. The details of the birds vary, however. This bird's carefully carved feathers, bare neck, and spread wings make it the Bini-Portuguese ivory most directly related to traditional art. It is quite similar to the metal bird idiophones (cat. no. 9), the reliefs of birds on plaques, and the large birds that once stood on the palace roof (fig. 3, p. 15). On a number of other ivory spoons, the birds hold medicine balls in relatively short beaks. Unfortunately, this bird's beak has broken off; the length of the beak and whether it originally held a medicine ball cannot be determined. The metal bird idiophones of traditional Benin art hold medicine balls, but unlike the birds with medicine balls on ivory spoons, they have long beaks. Birds on plaques have beaks of varying lengths, depending on the event being shown.

The Portuguese who commissioned ivory objects from Benin were probably following a pattern of patronage that began with earlier coastal trade along the western Guinea Coast. Portuguese official records, particularly customs tax listings, provide information about the trade in carved ivories, although no sources are directly mentioned. For example, tax receipts from the Cape Verde Islands for the years 1491–93 identify fourteen ivory spoons as having been purchased on the African mainland, but no more precise location is given (Curnow 1983, 7). Certain ivories, however, have been identified as coming from what is now Sierra Leone. The identification is based on cross-checking customs records in Lisbon (1504–05) with published accounts of ships' cargoes (1506–08); carved ivories arrived on ships containing goods that originated in the Sierra Leone region (Ryder 1964, 363–65).

Portuguese records also reveal that ivory spoons, from either the Sierra Leone region or Benin, were popular items to import. From 1504 to 1505, for example, 131 spoons cleared Portuguese customs (Curnow 1983, 28). Carved ivories were not part of a ship's official cargo. Instead, a diversity of individuals purchased ivories and took them to Portugal. Customs records show that the powerful governor of the trading fort at Elmina and a ship's boy each paid duty on three spoons (Ryder 1964, 363–64).

The original purchasers of the spoons either gave them to important patrons as gifts or sold them. Eventually, the spoons entered collections of the nobility, the intellectuals, and the wealthy of Europe. The collections comprised valuable, unusual, or supposedly magical objects, both natural and manmade. Objects such as European quartz goblets, Chinese porcelains, and "unicorn" horns were gathered with globes and other scientific instruments. These so-called curiosity cabinets, which to modern tastes seem rather a jumble, actually were attempts to organize mankind's rapidly expanding knowledge of the world.

Unfortunately, the identifications of the African ivories and other exotica were often wrong. Bini-Portuguese spoons were identified as Turkish in inventories of the collections of the Elector Augustus of Saxony (Dresden, 1595) and the Hapsburg Archduke Ferdinand I of Tyrol (1596). Cosimo I, the Medici grand duke of Tuscany, had no attribution at all on his five spoons in 1560. One spoon in a Copenhagen collection was even listed as Japanese in 1690 (Curnow 1983, 30–33). Other spoons were mistakenly identified as Indian, but since the Portuguese also purchased ivory in India, such an identification was at least plausible. Even today, scholarly disagreement persists about the sources of African carved ivories.

Provenance
Mrs. Robert Woods Bliss, before 1969

GLOSSARY

Aghadaghada. Circled-cross motif. A symbol of Olokun. Play on Edo word *ada,* meaning "crossroads" (cat. no. 7).

Aseberia. Multifigure sculpture with rectangular base that is used on altars (cat. no. 8).

Atolekpe hae. Name of special bead on oba's crown. Means "you can never touch a leopard's forehead" (cat. no. 2).

Ebe ame. River-leaf motif. A symbol of Olokun (cat. nos. 11–18).

Eben. Ceremonial sword with fanlike blade.

Edaiken. Crown prince.

Edo. Name of people, language, and, during some reigns the city and kingdom of Benin.

Egogo. Gong (cat. nos. 4, 10).

Emobo. Festival to drive away evil forces from kingdom. Held following Igue (cat. no. 4).

Ewaise. Guild of healers and diviners (cat. no. 4).

Ezomo. War chief. One of the Uzama (cat. no. 5).

Ibiwe. Palace association responsible for oba's wives and children.

Igue. Festival dedicated to strengthening the oba's spiritual powers.

Ikegobo. Altar of the hand (cat. no. 10).

Iron. Mock battle in which the oba's forces defeat the Uzama. Part of the Ugie Erha Oba festival honoring the immediate past oba (cat. no. 19).

Iwebo. Palace association in charge of regalia, foreign trade, and artists-craftsmen.

Iweguae. Palace association that held the household offices involving personal care of the oba.

Iwoki. Guild that guarded the royal firearms (cat. no. 19).

Iyerhuan. Large man's wrapper of hand-woven cotton with figurative symbolic designs (cat no. 4).

Iyoba or *Iye Oba.* Queen mother.

Manilla. Imported brass or copper C-shaped ingot used as trade currency. Related to the Portuguese word meaning "hand."

Oba. Divine king. Ruler of Benin in present second dynasty.

Odigba. High beaded collar.

Ofoe. Messenger of god of death (cat. no. 6).

Ogun. God of iron (cat. no. 4).

Ogiso. Original Edo ruling dynasty.

Ogiuwu. God of death (cat. no. 6).

Olokun. God of the sea or the great waters.

Oranmiyan. Son of the Yoruba divine king of Ife and supposed founder of present Benin dynasty.

Ora. Wife of Uwen, a state deity (cat. no. 5).

Osa. State priest, caretaker of the gods Uwen and Ora (cat. no. 5).

Osuan. State priest, caretaker of the gods Uwen and Ora (cat. no. 5).

Osun. God of medicine and healing (cat. no. 1).

Ubini. Non-Edo term for the kingdom. Probably from Ile-Ibinu, "The Land of Vexation."

Ugie Oro. Festival commemorating the sixteenth-century Edo victory over the Igala people of Idah (cat no. 9).

Uwen. Deified Osun specialist who came to Benin with Oranmiyan (cat. no. 5).

Uzama. Hereditary chiefs considered to be descended from those who brought the present ruling dynasty to power.

BIBLIOGRAPHY

Bacon, Reginald Hugh. 1897. *Benin, The City of Blood.* London: Edward Arnold.

Ben-Amos, Paula. 1976. "Men and Animals in Benin Art." *Man* n.s. 2 (2): 243–52.

———. 1978. "Owina N'Ido: Royal Weavers of Benin." *African Arts* 11 (4): 48–53, 95–96.

———. 1980. *The Art of Benin.* New York: Thames and Hudson.

———. 1983. "In Honor of Queen Mothers." In *The Art of Power, the Power of Art: Studies in Benin Iconography,* edited by Paula Ben-Amos and Arnold Rubin. Museum of Cultural History Monograph Series, no. 19. Los Angeles: Museum of Cultural History, University of California.

Blackmun, Barbara Winston. 1984. *The Iconography of Carved Altar Tusks from Benin, Nigeria.* Ph.D. diss., 3 vols., University of California, Los Angeles. Ann Arbor, Michigan: University Microfilms International.

Bosman, William. [1705] 1967. *A New and Accurate Description of the Coast of Guinea.* Reprint. London: Frank Cass.

Bradbury, R. E. 1973. *Benin Studies.* Edited by Peter Morton-Williams. London: Oxford University Press.

Connah, Graham. 1975. *The Archaeology of Benin: Excavations and other Researches in and around Benin City, Nigeria.* Oxford: Clarendon Press.

Curnow, Kathy. 1983. *The Afro-Portuguese Ivories: Classification and Stylistic Analysis of a Hybrid Art Form.* Ph.D. diss., 2 vols., Indiana University, Bloomington. Ann Arbor, Michigan: University Microfilms International.

Dark, Philip J. C. 1962. *The Art of Benin: A Catalogue of an Exhibition of the A. W. F. Fuller and Chicago Natural History Museum Collections of Antiquities from Benin, Nigeria.* Chicago: Field Museum of Natural History.

———. 1973. *An Introduction to Benin Art and Technology.* Oxford: Clarendon Press.

———. 1975. "Benin Bronze Heads: Styles and Chronology." In *African Images: Essays in African Iconology,* edited by Daniel F. McCall and Edna G. Bay. Boston University Papers on Africa, vol. 6. New York: Africana Publishing.

———. 1982. *An Illustrated Catalogue of Benin Art.* Boston: G. K. Hall.

Dark, Philip J. C., and Matthew Hill. 1971. "Musical Instruments on Benin Plaques." In *Essays on Music and History in Africa,* edited by Klaus P. Wachsmann. Evanston: Northwestern University Press.

Egharevba, Jacob. 1960. *A Short History of Benin.* 3d ed. (1st ed. published in 1934). Ibadan: Ibadan University Press.

Eyo, Ekpo. 1977. *Two Thousand Years: Nigerian Art.* Lagos: Federal Department of Antiquities.

Eyo, Ekpo, and Frank Willett. 1980. *Treasures of Ancient Nigeria.* New York: Alfred A. Knopf in association with the Detroit Institute of Arts.

Fagg, William. 1959. *Afro-Portuguese Ivories.* London: Batchworth Press.

———. 1963. *Nigerian Images, the Splendor of African Sculpture.* New York: Praeger.

Forbes, Henry O. 1898. "On a Collection of Cast-Metal Work, of High Artistic Value, from Benin, Lately Acquired for the Mayer Museum." *Bulletin of the Liverpool Museums* 1:49–70.

Forman, W., B. Forman, and Philip Dark. 1960. *Benin Art.* London: Paul Hamlyn.

Fraser, Douglas. 1972. "The Fish-Legged Figure in Benin and Yoruba Art." In *African Art and Leadership,* edited by Douglas Fraser and Herbert M. Cole. Madison: University of Wisconsin Press.

Gallagher, Jacki. 1983. "'Fetish Belong King': Fish in the Art of Benin." In *The Art of Power, the Power of Art: Studies in Benin Iconography,* edited by Paula Ben-Amos and Arnold Rubin. Museum of Cultural History Monograph Series, no. 19. Los Angeles: Museum of Cultural History, University of California.

Herbert, Eugenia W. 1984. *Red Gold of Africa: Copper in Precolonial History and Culture*. Madison: University of Wisconsin Press.

Hess, Catherine. 1983. "Quadrangular Bells." In *The Art of Power, the Power of Art: Studies in Benin Iconography*, edited by Paula Ben-Amos and Arnold Rubin. Museum of Cultural History Monograph Series, no. 19. Los Angeles: Museum of Cultural History, University of California.

Hodgkin, Thomas, ed. 1960. *Nigerian Perspectives: An Historical Anthology*. West African History Series. London: Oxford University Press.

Home, Robert. 1982. *City of Blood Revisited: A New Look at the Benin Expedition of 1897*. London: Rex Collings.

Kaplan, Flora S., ed. 1981. *Images of Power: Art of the Royal Court of Benin*. New York: New York University.

Luschan, Felix von. [1919] 1968. *Die Altertümer von Benin*. Reprint (3 vols. in 1). New York: Hacker Art Books.

Musée de l'homme (Muséum national d'histoire naturelle). 1932. *Exposition de bronzes et ivoires du royaume de Bénin, 15 juin–15 juillet 1932*. Paris: Muséum national d'histoire naturelle, Musée d'ethnographie, Palais du Trocadéro.

Nevadomsky, Joseph. 1984a. "Kingship Succession Rituals in Benin, Part 2: The Big Things." *African Arts* 17 (2): 41–47, 90–91.

———. 1984b. "Kingship Succession Rituals in Benin, Part 3: The Coronation of the Oba." *African Arts* 17, (3): 48–57, 91–92.

———. 1986. "The Benin Bronze Horseman as the Ata of Idah." *African Arts* 19 (4): 40–47, 85.

Nevadomsky, Joseph, and Daniel E. Inneh. 1983. "Kingship Succession Rituals in Benin, Part 1: Becoming a Crown Prince." *African Arts* 17 (1): 47–54, 87.

Pitt-Rivers, Augustus. [1900] 1976. *Antique Works of Art from Benin*. Reprint, with introduction by Bernard Fagg. New York: Dover Publications.

Quarcoopome, E. Nii. 1983. "Pendant Plaques." In *The Art of Power, the Power of Art: Studies in Benin Iconography*, edited by Paula Ben-Amos and Arnold Rubin. Museum of Cultural History Monograph Series, no. 19. Los Angeles: Museum of Cultural History, University of California.

Read, Charles Hercules, and Ormonde Maddock Dalton. [1899] 1973. *Antiquities from the City of Benin and from Other Parts of West Africa in the British Museum*. Reprint. New York: Hacker Art Books.

Roth, H. Ling. [1903] 1968. *Great Benin: Its Customs, Art and Horrors*. Reprint. New York: Barnes and Noble.

Ryder, Alan F. C. 1964. "A Note on the Afro-Portuguese Ivories." *Journal of African History* 5 (3): 363–65.

———. 1969. *Benin and the Europeans 1485–1897*. Ibadan History Series. New York: Humanities Press.

Shaw, Thurstan. 1978. "The Art of Benin through the Eyes of the Artist, the Art Historian, the Ethnographer and the Archaeologist." In *Art and Society, Studies in Style, Culture and Aesthetics*, edited by Michael Greenhalgh and Vincent Megaw. New York: St. Martin's Press.

Talbot, Percy Amaury. [1926] 1969. *The People of Southern Nigeria*. 4 vols. Reprint. London: Frank Cass.

Tunis, Irwin L. 1981. "The Benin Chronologies." *African Arts* 14 (2): 86–87.

———. 1983. "A Note on Benin Plaque Termination Dates." *Tribus* 32:45–53.

Willett, Frank. 1985. *African Art*. (First published in 1971.) New York: Thames and Hudson.

ROYAL BENIN ART

Designed by Christopher Jones

Studio photographs by Jeffrey Ploskonka

Typeset in Berkeley Old Style

Printed on Warren Lustro Gloss
by AmeriPrint in Vienna, Virginia